'Mindful drawing might bring you closer to not just an understanding of yourself, but also an understanding of the power of art. Greenhalgh's mindful drawing turns all of life into an art museum for us to see and appreciate through time and effort. If you're looking for peace of mind, it might just be a doodle – albeit a focused, mindful doodle – away.'

BOB DUGGAN
CONTRIBUTOR TO 'THE BIG THINK'

Mindfulness *in* Drawing

Meditations on Creativity & Calm

Wendy Ann Greenhalgh

Leaping Hare Press

Quarto

First published in hardback in 2015.

This hardback edition first published in 2023 by Leaping Hare Press,
an imprint of The Quarto Group.
One Triptych Place
London, SE1 9SH
United Kingdom
T (0)20 7700 6700
www.Quarto.com

A catalogue record for this book is available from the British Library.

ISBN 978-0-7112-8825-6
Ebook ISBN 978-0-7112-8826-3
Audiobook ISBN 978-0-7112-8874-4

10 9 8 7 6 5 4 3 2 1

Design by Ginny Zeal

Printed in China

CONTENTS

INTRODUCTION

Everyone can draw. Far from being a
rare gift, only possessed by the 'artists' among
us, drawing can be as natural and instinctive to us
as breathing — if we let it. When practised mindfully,
drawing has the power to effortlessly lead us into a
deeper relationship with ourselves and the world
around us, turning a simple act of creativity
into play, into a dance of movement,
a way of seeing deeply and connecting
profoundly with life.

BEGINNING TO DRAW

As children, we draw — instinctively, and generally without too much thought, we put crayon to paper and we make marks. We don't generally have a sense of good or bad drawing. We just draw. And that is what this book is about — just drawing.

WHEN I WAS SEVEN YEARS OLD, I won the class prize for art. It was nice to go up on stage at the end of term and receive my copy of *Wind In The Willows*. People clapped. But I wasn't especially hung up on my prize, because I didn't really understand what a prize was. A prize for art — of all things — was even more of a strange concept, because drawing wasn't anything special, surely? It was just something I did and enjoyed, along with all the other children in my class.

It was only many years later, as a teenager, that drawing really became important to me. Faced with a period of sudden, chronic illness, I rediscovered the magic of paper and pen. Going crazy with boredom and frustration one day, I grabbed a pad and a biro, stuck my foot out, and started drawing it. Toes, ball, instep, arch and ankle gradually took shape on the page. And while my hand sketched, I forgot my worries and became completely absorbed in the creative activity before me. I continued to draw in the months that followed, and once I recovered, I never put the pens and pencils away. That moment in bed, as I drew my own foot, was the moment,

though I didn't know it at the time, that drawing became significant for me, the moment I became an artist. Although I've never won another prize for art, what I discovered as a teenager, and what I find every time I come to a blank page, is that drawing has a profound effect on my state of mind – and it is this transformative, mindful aspect of drawing that I value so much and which, as a teacher, I'm compelled to share.

Mindfulness & Drawing

So what happens when we draw? And how and why does the simple act of drawing have such an impact on us? For a long time I had no answers, nor did I particularly seek them. I was happy just to be creative and enjoy making marks on pieces of paper; but in my early twenties, after some years drawing, and even briefly working as a freelance illustrator, I discovered mindfulness meditation, and gradually what had been a mystery became clear.

What I discovered was that the practice of mindfulness meditation evoked the same responses from me that drawing did. The state of mind I entered during meditation was quali-

I sometimes think there
is nothing so delightful as drawing.

Vincent Van Gogh (1853–90)
DUTCH POST-IMPRESSIONIST PAINTER

tatively no different from the one I entered when deeply absorbed in drawing. From this point on, my creative life and my meditative life proceeded hand in hand; I went off to study Fine Art at university, I went on meditation retreats, I practised and I learned. And what I learned was this, and it was surprisingly simple.

Finding a Focus

Mindfulness practice and mindfulness meditation, like many other meditative traditions, provide meditators with a focus for their mind. In mindfulness practice, this focus is most often the sensations in the body and the movement of the breath as it flows in and out. In other meditative traditions a mantra might be used, or a candle flame, or an image. What these different focuses all do is give our busy, thinking minds something to rest on, something to dwell in, something to come back to when the rush of thoughts, memories, fantasies, futures, pasts, emotions, attractions, aversions or desires threatens to sweep us away from the here and now.

In mindfulness practice, the focus of the body and the breath is our anchor, securing us so that we aren't tumbled around as greatly by the teeming activity of our thinking minds. When we are practising the mindfulness of drawing, it is the movement of the pen across the page, the coordination of eye and hand, and the object we are drawing that become our mindful focus. And having this firm focus is essential,

because without it we cannot begin to calm our minds, cannot hope to find space in our heads and in our hearts, or to come into a broader state of awareness, of simply being.

As modern humans, in industrialised, technologised societies, there's no doubt that our minds are conditioned for overactivity. They jump around from one thing to another, constantly stimulated – or even overstimulated – by a barrage of media, social media, TV, internet, traffic, crowds, work, busy social lives and family lives. The truth is that for most of us, unless we make a special effort, there are very few moments of silence, tranquillity or peace in our days. It's harder than ever for us to find a space to calm and quiet our minds, to simply *be,* and yet, more than any other generation, we are probably most in need of doing so.

It's harder than ever for us to find a space to calm and quiet our minds, to simply be

If focusing on one thing for more than five minutes is our problem, the mindfulness of drawing offers a wonderfully simple, low-tech and creative solution. And with its unique combination of both physical and mental activity, with its coordination of hand, eye and object, the mindfulness of drawing, the simple act of making marks on a page, can be particularly helpful in getting busy, overactive minds to settle and focus.

BECOMING ABSORBED

As we continue to draw and to practise the mindfulness of drawing, or any mindfulness practice, something begins to happen. Held steady by the anchor of mindfulness, the buffeting currents of our thoughts and emotions no longer toss us around so much.

WE HAVE THE EXPERIENCE of holding steady with our focus (our breath or our drawing) – holding not in a tense, effortful way, but in a relaxed, open manner. This holding steady, this absorption, happens when we are fully immersed. It happens when – after some time spent mindfully focusing – a bit of space opens up in the stream of thoughts and emotions in our heads. This is the first sign that we are moving out of *thinking-mind* and into *being-mind*.

At first, these moments of total absorption, and the consequent dwelling in being-mind, may be very brief, just a matter of a few seconds. We may become aware that the chatter in our heads has quietened, or that we feel somehow suspended in or over a stillness, with just our bodies, our breath or our drawing for company. At these moments everything feels very close, very immanent; our senses may be heightened, we may feel like we're drawing with our whole being, listening with our whole being to everything. As we continue to practise, these periods of absorption and stillness become longer and we find ourselves in them more frequently or easily.

This distinction between thinking and being is important. Absorption isn't the same as concentrating or thinking very hard and single-mindedly about something – a problem at work, for example. Absorption happens when we move out of thinking-mind and into being-mind; away from analysing, conceptualising, telling stories in our heads, or trying to work things out. Absorption is about *being* at one with something and just doing it as if it's the only thing in the world. It's the first sign that we're expanding and opening into a different state of being, a new kind of awareness, and it is characterised, when we're drawing, by what we might call flow.

Getting in the Flow

Being in the flow is something that all creative people – every person who has *ever* engaged in a creativity activity – will recognise. It's that moment when the hand holding the pen seems to move across the page of its own volition; eyes move between paper and object, drawing instinctively; there's no sense of effort, only of enjoyment. There may not even be a sense of 'us' drawing, just a feeling of being totally immersed. When we're in the flow, we make creative choices intuitively, without over-thinking. When we are in the flow, we are completely at one with the activity. I cherish those moments; drawing – sitting in front of a flower or plant, sketchbook on my lap, pen moving peacefully; or writing – the lines of a new poem seeming to scribble themselves across the page.

Mihály Csikszentmihalyi, a Hungarian professor of psychology noted for his work on creativity and happiness, first proposed the idea of Flow (sometimes called Zone) more than twenty years ago, and has spent years researching and writing about it. But Csikszentmihalyi's concept of being at one – totally absorbed in an activity – is something that artists and mindfulness practitioners have known about for many hundreds, indeed, thousands of years. And the mindfulness of drawing has been the meditative activity that allows me to access this state of effortless effort most easily. When I am in Flow, I am no longer in my thinking-mind; indeed, I lose to a great extent my sense of self. Instead I find myself opening out to the simplicity of just being, just drawing.

Simply Being

What the mindfulness of drawing offers us, if we choose to follow its path, is the opportunity to engage with ourselves and with life from a completely different standpoint. With our thinking-minds calmed, fully absorbed and in the flow, we come into a state of being characterised by a sense of open, spacious awareness. We no longer need to think of the future or the past, we are only in the present moment. We don't have to force anything or make anything happen, it happens naturally – it flows. We don't even have to work anything out; our desire to conceptualise and analyse falls away and we rest in a feeling of spacious awakeness, a free and open awareness of

everything. Thoughts and emotions may arise when we're in this state of mind, but they are like a leaf or twig, carried along on the surface of a stream, there – and then gone, while the pure, clear water of our awareness keeps flowing.

I cannot tell you how free, how light, how joyous that state of simply being can be. It's hard to describe it – but if you wish to experience it for yourself, pick up a pencil, sit, draw, find out for yourself. And when you do, you'll discover the mindfulness of drawing's final gift to you.

Opening to the World Around Us

When our thinking-minds are quieted, when we are absorbed in the flow of drawing, of simply being – something quite magical begins to happen. Less preoccupied with the whirl of thinking and planning in our heads, we begin to notice the world around us.

At first we might notice small things; colours become more intense, shadow and light more vivid, the old vase with its cracked glaze that we've been sketching seems full of extraordinary detail, detail that we never really noticed before – and it's been sitting on our kitchen window-sill for five years. Or we take a walk to the corner shop for milk, but get caught up on the way with patterns of frost on iced-over car windows and have to stop to take a look.

Suddenly there are things to draw *everywhere*. On our walk to work, red rosehips droop on the tops of straggling rose-bushes in our neighbours' autumn gardens. On the bus, the nobbled nose of an old man or the thick shock of hair on a teenager's head leaves our fingers itching for a notepad and pen. At our desk, we watch the movement of sunlight across our workstation, illuminating the glass of water by our key-board. In the park, instead of hurrying, we sit, our oil-pastel halted on the page, just feeling the wind, letting the sound of the children in the playground wash around us, just breathing, just being, before resuming our drawing of a tree.

The gift of mindfulness, the gift of awareness, is that in clearing our minds, pausing and coming into the present moment, in simply *being* – we are offered the whole world, and without all the distractions of the thinking-mind to get in the way, we are able to open to it, more fully, more effort-lessly, than we ever have before.

Everyone Can Draw

And all this is open to you. You can experience it too. Con-trary to what many of us are told when we're young (I've lost count of the number of people who've told me stories of teachers or even parents criticising youthful drawing efforts), contrary to these messages, *everyone,* I repeat – *every-one* can follow the path of mindful drawing. *Everyone* can draw. There are no exceptions. Absolutely none. The only thing that

actually stops people from drawing is the voice in their head that says they can't, they shouldn't, they're rubbish. But what that voice tells them isn't true. And much of my work as a teacher of mindful drawing is about supporting people to gently and sympathetically ignore these voices and discover that they can indeed draw, that they always could.

Being creative and drawing is completely natural to us. With no conditioning and no instruction, as soon as we can hold a crayon, we start to make marks, we start to explore mark-making, we start to express ourselves and enjoy the act of drawing. It is, as they say, a no-brainer. The problem only starts when the thinking-mind gets involved. What this means is that this book is for *everyone;* the never-started artist who wants to get going, just as much as the experienced artist who wants to rediscover drawing in the instinctive, open way they had as a child.

Beginner's Mind

The important thing to hold on to at this point is the childlike curiosity and enjoyment in drawing that we all experienced when we were young. Come to drawing as if you've never done it before. Come to drawing with no expectations. Come to drawing with a curiosity about the marks you could make and the world you could explore. Come to drawing as a beginner. Being a beginner is the best thing to be, because as beginners we can simply *be*.

In Zen Buddhism there is a term – *soshin* – that translates as *beginner's mind*. When we practise beginner's mind, we come to our experience afresh each time. When we draw with beginner's mind, we can allow the process of drawing to be our friend, our guide, our playmate. When we draw with beginner's mind, we have no expectation of being proficient, of being a Michelangelo or Da Vinci – we're just a beginner, we're just drawing. Beginner's mind allows us to focus on the *process* of drawing, and to let go of our preoccupation with a *product*. By product, I mean something finished. I mean those drawings that are supposed to compare favourably with every other drawing that we've ever done, or that anyone else in the room has done, or indeed *any* drawing that anyone in the world has *ever* done! Product – who needs it? Such pressure, all completely needless, and completely joyless.

So as you continue to read this book, pause, remember how it was to draw as a child, and as you practise the drawing exercises in the chapters that follow, and explore the qualities of focus, absorption, flow and simply being, allow yourself that beginner's mind. Allow yourself to just draw.

◆

All children are artists. The problem
is how to remain an artist once he grows up.

PABLO PICASSO (1881–1973)
SPANISH ARTIST

◆

Preparing to Draw

Zen Buddhism was a major influence on the development of the beautiful, graceful Japanese tea ceremonies, in which the making, pouring and even drinking of tea becomes a mindful ritual. Why not approach your drawing with the same spirit of mindfulness? Instead of just throwing some blunt pencils on the table, and tearing a scrap of paper from the bottom of a shopping list, why not make preparing to draw a meaningful ritual, that signals that it's something special to you, and that something important is about to begin?

As you sharpen pencils, and choose a nice sketchbook, arranging them on an uncluttered table, why not also think about the conditions that have arisen that allow you to draw? The tree that made the paper, the fire that created your charcoal, the circumstances that allow you at this moment in your life to sit down and draw are all present in some way. Even if you draw on an iPad – clean the screen, think of the plastic from oil, the metal from the Earth, the ingenious human minds that have created the technology that is now going to contribute to this moment of drawing for you. Even the gift of having the time to draw in our busy lives can be acknowledged in our few moments of quiet, mindful preparation of our materials.

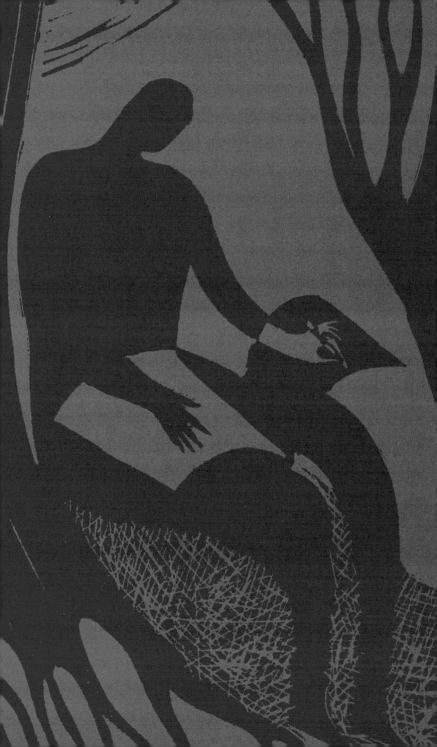

JUST DRAWING

*The wonderful thing about the path
of mindful drawing is that it is an entirely
practical path. Young or old, rich or poor, irrespective
of culture or gender — we can all experience this
active, creative mindfulness practice. It's a dynamic
process, which invites us to engage with awareness
not just with our minds, but with our bodies too,
with our whole being. All we need do is — do it.
Just draw, and all the rest follows.*

JUST DRAWING

So how can we make a start on the path of mindful drawing? The truth is we've probably strayed onto it already through the act of doodling, and in this simple practice many of the profound truths of mindfulness and drawing are contained.

DOODLING MAKES IT ALL SOUND a little throw-away, though, doesn't it? Perhaps *just doodling* doesn't quite have the same ring for you as *just drawing*. Maybe it seems a little less *Zen*, a bit more mundane. But don't underestimate doodling just because of the name. Instead, let's get to the heart of doodling's potential by asking the same question about it that we asked about drawing. What happens when we doodle? What is going on? The answer is that doodling is drawing without any particular object in mind, no destination, no aspiration. It's a kind of mark-making that is completely instinctive and as such it has some distinct advantages, and much to teach us about mindfulness.

> *Doodling is drawing without any particular object in mind, no destination, no aspiration*

Out of the Head & into the Body

Two things are principally happening when we doodle, which in combination make it a great mindfulness practice.

DRAWING EXERCISE

MINDFUL DOODLING

Let's try a simple drawing exercise. I suggest you try it for five to ten minutes to start with.

● Get a piece of A4 paper and a pencil or a pen. Sit comfortably, holding your pencil as you would normally. Keep the tip resting on the page and close your eyes.

● Take a few moments to focus on the feeling of your pencil between your fingers. This is something we do almost every day – we write, we scribble notes, we sign our name, but very rarely do we pay attention to how it actually feels to hold a pen in our hand.

● See if you can notice the different places the pencil presses against your skin. Is it resting on a knuckle or on the soft pads of your fingers? Is the surface rough or smooth? How does it feel? Experiment with how you hold the pencil. Are you holding it tightly or with a loose and relaxed grip? Can you loosen or tighten your hold so that it feels poised and yet still relaxed?

● Start to make some simple shapes on the page – all the time keeping your eyes closed. Make shapes simply because it feels good to make them. They might be continuous circles or spirals, zig-zags, straight lines, wavy lines, geometric type shapes, anything at all, just one or a combination of all.

● Keep your eyes closed and resist the urge to peek. Don't try to draw anything in particular; you're not drawing either from life or from your imagination here, you're just doodling, just making marks, just making marks that feel instinctive and enjoyable to make.

● When you feel yourself getting a little tired or bored with one shape, change your focus and draw another shape. Keep coming back to the sensation of your hand drawing, brushing against the paper, holding the pencil. Keep drawing – keep doodling just what feels good, the shapes you feel you instinctively want to.

Perfect Timing

It can be helpful with some of these drawing exercises to set a timer. Setting an alarm means you don't have to keep an eye on the clock; you can just let yourself become absorbed in the activity. Without an alarm we can often get preoccupied with time. Have we done the activity for long enough? It *feels* like five minutes, but when we open our eyes, peeking at the clock – we find only one minute has gone by! And in wondering and peeking, we've lost that flow, that absorption in the activity we were moving towards.

Using a timer also replicates the experience of being in a workshop, and allows us to open to doing things in different ways, trying things for a longer or shorter time than we might normally. We might feel we could never draw the same thing for ten minutes, for example, but are then surprised to find – as the alarm goes – that we can, and not only that, but we wish we had more time. Likewise, we might deem it impossible to draw someone's face in five minutes, and then discover we've done a pretty good job of it!

There are many free mindfulness timers and Apps online, which can be downloaded to computers or phones. Or you could set your alarm. Why not give it a try?

Firstly, freed from the requirement to make our drawing look like anything and immersed in doing only what feels good and natural, the voice in our head that can start up – telling us that we can't draw, or that what we're doing isn't any good – is effectively silenced. There is nothing for our inner-critic to latch on to, because doodling is about the process of making marks, not a finished product. No one ever held up our doodles in class and pronounced, 'Well, this simply isn't good enough!'

This kind of abstract image, then, has no definitive means by which to judge it, and so our heads, our thinking-minds, are much less likely to get involved in the process. Of course, they might still *try* to get a word in, with little whispers like: *You're not doing this right.* If this happens, the best thing to do is to notice that little story-telling voice, mentally give it a nod of acknowledgement: *Yep, I hear you're there, but listen, I'm* just *doodling, so you don't need to get involved right now.* Then you can go back to doodling.

The second thing that doodling does for us is bring us right back to the physical act of drawing; after all, there's nothing else going on. We're not looking at anything in particular. We're not

A drawing is simply a line going for a walk.

PAUL KLEE (1879–1940)
SWISS-GERMAN ARTIST

copying anything or transposing it to a page. We're just making marks. In the exercise above, I suggested you pay particular attention to the sensations in your hand – of course, if you're on the phone, doodling in the margins of the electricity bill, you may not be aware of this in quite the same way. But the truth is that our hand is still giving feedback to our brain even when we're not consciously aware of it – and I believe that many of the shapes we make when we unconsciously doodle are the result of our subliminal enjoyment of the physical process of making them.

When we practise the mindfulness of drawing, however, our aim is to become more aware, more alive to our experience of mark-making and how it affects us. So placing a particular focus on the hands can be a really useful thing to do – and it's something that we will return to again and again throughout this book. Whenever we're drawing, whether it's because we're following an exercise, or are just out and about with our sketchbook, we benefit from taking a few mindful moments, both before and while we draw, to connect with our hands. This reminds us that drawing involves the whole body and even the breath, not just eyes and hands.

Waking to the Body

I think my first really concrete experience of the physical nature of drawing came on a summer school I attended before I went to art college. It was my first time working in a proper

artists' studio, and the large space and the excellent tutor encouraged me to break out of the A4 page, to work *big*. As an illustrator, and even in my own drawing for pleasure, I'd become used to working on quite a small scale, and I don't think I'm alone in that experience. Many things can influence our choice to draw small: constraints of space – working on a kitchen table, for example; constraints in confidence – it takes quite a lot of confidence to make a grand gesture with our drawings; and sometimes even financial constraints – big pads of cartridge paper can be expensive.

However, that summer, I was encouraged to think big – and it was a transformative experience. By then I had started practising mindfulness too, so I was able to make connections between what was happening in the studio, and what was happening when I sat and meditated. On one particular day of the course, the tutor tacked up a huge piece of card on a

Placing a particular focus on the hands can be a really useful thing to do

white wall already scarred and marked by the paint and charcoal of dozens of other artists, and suggested I just go for it. At first I was tentative; I'd never drawn or painted on this scale before. Doubts surfaced about my capabilities. Fears arose about whether I'd actually be able to do it. But once I'd started, making the first mark on that blank piece of paper, in the same spirit as a child taking their first jump off the top

diving board, I soon began to enjoy having so much space. Standing – instead of in my normal sitting pose – I drew and painted for hours.

My marks got bigger, bolder. I brought in swathes and washes of colour. Lines journeyed across the page, extending my arm and shoulder to their full reach. I stooped to fill the bottom of the page; I stretched to reach the top. And as I became more and more absorbed, my habit of mindfulness kicked in, and I began to notice something. I was drawing with my whole body – not just hands and eyes, but wrists, forearms, elbows, shoulders, my back and chest, my hips and legs and even my feet were all involved in the making of marks. And even my breathing, I became aware, was part of the drawing process too. I discovered that drawing was a dance, and I'd never felt so free with it. They almost had to physically evict me from the studio at the end of that course.

This awareness of the physical nature of drawing, this relationship to it as an act of the body, is something that hasn't left me. My perspective changed irrevocably that day, and it had some profound effects on my mindfulness practice, too.

◆

I rarely draw what I see –
I draw what I feel in my body.[1]

BARBARA HEPWORTH (1903–75)
BRITISH SCULPTOR

◆

When Drawing, Draw

Here, I feel I should make a confession. I'm someone who is naturally very up in my head. Like a lot of creative people, I conceptualise, visualise and analyse brilliantly. I can look at things from a hundred different angles, and then probably find some more. I think I can safely say that my thinking-mind is pretty well developed. But moving into *being-mind,* that has been a challenge, and I'm still working on it. Every day. But the more I bring my awareness out of thinking, out of the small, contained little space of my mind – and instead go *big,* moving into the expansiveness of my body with its direct sensory experiences, the better I am able to dwell in awareness, the more deeply I am able to open to life.

This was the mindfulness practice the historical Buddha, Siddhãrtha Gautama, taught. 'When walking, walk; when standing, stand; when sitting, sit; when lying down, lie down,' he instructed. In other words, *be* with the experience, the physical feedback of being in the body, and do only this thing. Leave the thinking-mind behind. He may as well have added, 'When drawing, draw.' Just draw. Draw with the whole body, and allow yourself to rest in the direct physical sensations of drawing. When we do this, we have a sense of being entirely in the present moment, completely immersed in our direct experience. This is the experience of simply being, that open, spacious awareness I talked of in the Introduction. The following exercises will give you a taste of this.

DRAWING EXERCISE

MINDFULNESS OF THE BREATH

For this drawing exercise, I suggest you use charcoal or pastels, and also a large piece of paper. Many of the cheap one-pound or one-dollar stores now sell very affordable A3 or even A2 sketchbooks, and while the quality of the paper isn't great, they're absolutely fine for mindful drawing exercises and drawing experiments generally, so I encourage you to go and get one.

If you only have a small pad, I suggest you combine a few smaller sheets to size up to A1. Stick it all together with masking tape – you can draw over masking tape, you can't draw on plastic sticky tape – and then tape your big sheet of paper to a wall. Only use the wall if it's one that won't get offended if it gathers a few drawing marks on it; otherwise stick it to the floor. Floors, thankfully, can be easily washed! If you have a big table or desk you can clear, you could also work on this. In fact, I would encourage you to do the following exercise in a variety of different positions – standing, sitting at a table, sitting or on your knees on the floor – because each variation will change how you experience your body as you draw and therefore, to some extent, the marks you make too.

Once you've prepared your materials, I'd like you to try the following. I suggest you allow about ten minutes for this.

● First, with your eyes closed, hold your charcoal, connecting with the feeling of it in your hand. It's going to feel very different to a pencil. You may even hold it in a different way. In the spirit of beginner's mind, explore charcoal and hand in the same way you did for the earlier exercise. In future, I'm going to assume you do this *every* time you start drawing. Once you've done this, take some moments to focus on your breath.

● Follow your breath in and out of your body, focusing on the point in your torso where it's easiest to feel it. For some people this is the chest, for others the solar plexus above the belly button, for others it may be lower down in the belly. Rest your awareness in different locations until you find the spot that feels comfortable to focus on and where you can clearly feel the breath.

• For a while, just rest with this sensation of the breath, using it as your mindful focus. See if you can notice the complete cycle of a breath. All the way in, and all the way out.

• You may notice that sometimes a breath is deep and full, other times shallow or tight. Don't try to control the breath, let it breathe you. Remember, you don't have to do anything, or make anything happen – all you need to do is relax, right now, and breathe.

• As you do this, you may notice your mind wandering off, pursuing some idea or other. If that happens, don't worry – that's just the thinking-mind doing what it does. Just gently bring it back to your focus, which is currently the breath. When you feel that you're a little more centred, with your eyes still closed, you can place your charcoal on the paper.

• Keep focusing on your breath, let it flow naturally, but now allow your hand, your wrist, arm and shoulder to start to move with the breath. Let the movement just emerge, see what shapes naturally come from feeling the breath and moving with it. Some people find they want to make small marks, others, large ones. Some marks are circular. Others are spiky or in straight lines. This is like doodling; there are no rights or wrongs. Just marks.

• Keep your focus on the feeling of your whole body as you draw and also on your breath. This is a butterfly light attention, moving, flickering, between the two. Breath, body, mark. Breath, body, mark.

• Notice how when you move your hand, your wrist and shoulder move too. Where else can you feel your drawing? In your back? Your hips or legs? Keep that light sense of the breath and of your body.

• Notice, if you can, if anything becomes tense, and soften around it if possible. If it's not possible, just allow the tension to be there.

• When you've finished drawing with the breath, keep your eyes closed for a few more moments and notice the sensations in your hands and how stillness feels. Then you can open your eyes and look at the marks you've made.

DRAWING EXERCISE

MINDFULNESS OF THE BODY

The next two drawing exercises follow on from the mindfulness of the breath and can be done on the same piece of paper, with the same materials. They are both extensions of the mindfulness of doodling. Allow at least ten and up to twenty minutes for these mindfulness practices. And make sure your piece of paper is securely attached with masking tape to the floor, wall or table before you start.

Part One

Still with your eyes closed, you're going to draw with your awareness on your whole body as you make your marks. Drawing on a large scale will assist you in this, as drawing from one side of the paper to the other will require shifts in weight, movement of legs, back etc.

• Start your drawing session with a few moments of awareness of the sensations in the hands and of your breathing. This will be your standard checking-in activity from now on.

• Draw the shapes and doodles that feel good. Making whatever marks you want. Explore movement. This first time, I suggest you do this exercise in silence, but this can be a lovely thing to do with some favourite music on. The rhythms and sounds translate themselves into the marks we make on the paper, until a whole song can find itself transposed into a drawing on the page.

• Allow your body to relax; feel drawing as you would a dance. Keep that light sense of the breath, perhaps just by checking in with it occasionally. When we do this, we sometimes notice that our breathing is a little 'held', or restricted, a sure sign of tension in the body. Check in with your hand from time to time, too, and how you're holding the charcoal.

• While you're drawing, experiment with how you make marks. Draw with the tip of the charcoal, but also with the side. Draw fast, and draw slow.

• You should definitely try drawing with your non-dominant hand, switching the charcoal over to draw with the less familiar, less easily controlled side. You can

also experiment with drawing with both hands, and indeed, after you've been drawing for a while you could try drawing with your fingers, pulling the tips across the page, smudging the charcoal – noticing the sensations. Charcoal and pastel also often leave little crumbs behind on the paper, and it can be fun to put a finger on one of these, if you find one in your travels, and draw by pushing it around. How does that feel?

• Draw like this for ten to twenty minutes. Draw with the curious attitude of a child. Draw with beginner's mind. Play.

• When you're done, do your usual mindful check-out. Stand or sit still, noticing how this feels, checking in with the breath and the hands before opening your eyes.

Part Two

Turn your paper over, or prepare another large sheet. You're going to do the same exercise again, but this time with your eyes open. You'll still have that focus on the body, on how it physically feels to draw, and make different kinds of marks, but with your eyes open you'll now have a visual reference point too. You will probably start to make marks based not just on how they *feel* to make but also on how they *look*.

• Check in as normal and start to draw in the same way that you did for the first mindfulness of the body exercise. Eyes open this time, seeing what you're doing. How is it different now your eyes are involved in the process?

• Do you enjoy the feel and appearance of circular or angular, regular or chaotic marks? Try scribbling. Try dotting. Try cross-hatching, stippling, shading, smoothing. Try thick lines and thin lines. How many different marks can you make with the same piece of charcoal?

• Experiment, again with that curious, light-hearted attitude of a child.

• Continue for ten to twenty minutes, making sure you switch to your non-dominant hand at least once.

• Finish, as always, with a few moments of stillness.

Focus, Absorption & Flow

Once you've had your own experience of mindful drawing, you'll begin to understand how focus develops into absorption and absorption into flow. I find that when I'm drawing I become effortlessly *drawn into* what I'm doing. The combination of my awareness of hand moving, body breathing, that light, focused attention to the marks on the page, lead me out of my thinking-mind and into my being-mind, in a very direct and concrete way.

Many of the people I've worked with in workshops and on retreats have shared how they find it easier to move into that state of absorption and flow when they're drawing than they do if they just sit down and try to meditate. They also tend to report that they can hold their focus and stay absorbed for much longer than when they're just sitting in meditation.

When we're drawing, we become so absorbed that five minutes can feel like ten, or only sixty seconds. We are simply in the timelessness of the present moment. As we become absorbed in the act of drawing, our thinking, analysing minds are silenced to a greater extent too. Indeed, there is probably only one major hindrance to the absorption and flow of the mindfulness of drawing, and it crops up again and again.

DISCOVERING THE INNER CRITIC

What often emerges when we open our eyes and start looking at our drawings is the voice of the critic in our heads. Our inner critic is the whisper in our ear that questions our abilities and derides our creative efforts.

WHAT DID YOU DISCOVER? Were you able to stay as focused and absorbed when you did the final mindfulness of the body practice, or did negative thoughts and commentaries start to get louder once you could see just what you were drawing? Did you start to judge the marks you were making?

My own inner critic jumps in particularly quickly if I attempt any life drawing. The human form is one of the hardest things to draw and, if I'm honest, life drawing has never come easily to me. These days, too, I draw more infrequently, mostly on retreat or as a mindfulness practice, so it's very easy for my thinking-mind to leap in as soon as I put pen to paper. *Oh my goodness,* it starts up – almost as soon as I've made one mark, *that isn't very good, is it? You used to be much better at this. Look, that person's drawing is* excellent, *but yours… Call yourself an artist?*

Our inner critic is the whisper in our ear that questions our abilities and derides our creative efforts

Pause Often

In the exercises in this chapter, I suggest taking a mindful pause at the beginning and end of our drawing practice, or as a way of dealing with our inner critic; but you don't have to use the mindful pause just when you're drawing – this little mindfulness time-out is great to use at all times of the day and at any moment in your life. Sitting at the bus stop, or in traffic, you can pause, notice the breath and the sensations in the hands. Stressed at work? Pause. Just sit in your chair, connecting with the feeling of your body as you sit, following the in and out of your breath. In a rush? Pause. For a few moments slow down just a little, breathe, notice any areas of tension in your body and see if you can relax them a little. Walking to the shops? Pause. Stop to look at the leaves on the trees, the sun against a building, feel the wind on your face.

Pausing means you are coming into the present. Pausing means you are coming into your body and reconnecting with it, through the senses, through the breath. Pausing means expanding into the moment, instead of feeling cramped by it. Pausing means you are moving out of thinking and doing and into being. Seed these moments of presence into your days, and see just what a difference they can make.

With eyes shut we become acclimatised
to resting in the being-mind

Learning to Live with the Inner Critic

For most, if not all of us, this particular manifestation of the thinking-mind is somewhat inevitable. Thinking, comparing, assessing is what our minds are designed to do, and they've formed a habit of turning these capacities into judging ourselves and others over many years. So there's no need to worry if this is the case for you, because there are mindful strategies for dealing with it.

Doodling with our eyes closed, or (as we'll discover in the next chapter) drawing without looking at the page, are great ways to sidestep the process of self-criticism. Of course, at some point we might want to look at what we're drawing! But initially these not-looking practices are very useful, because with eyes shut we become acclimatised to resting in the being-mind. And this means we're more likely to notice the thinking-, judging-mind getting involved when we open them again. If we're able to notice this moment when judging gets involved in the drawing process, then we're less likely to get caught up in it, believing every word our inner critic utters. If at some point in the drawing process your inner, critical voice does become apparent, and it probably will, then the following practice will help you.

The Mindful Pause

• As soon as you notice the inner critic piping up and judging, either during the exercises described previously or at other times, the first thing to do is *pause*. Give yourself some space.

• Stop drawing. Let your hand rest on the page. Come back to the feeling of the pencil or charcoal in your fingers. Come back to that light sense of the breath flowing in and out of your body.

• Stay with this for a while, just resting in these physical sensations. Coming into our body, directly and simply is absolutely the best way to deal with the thinking-mind, especially when it's gone into criticising mode.

• Don't offer the voice in your head a response. Don't talk back. If it says: *That's rubbish!* – don't reply with counter-arguments. If we talk back it just feeds the thinking process, escalating it, until you're arguing with your own critical inner voices.

• All you need to do is acknowledge that the critical voice is there, and stay with the focus of your hands and your breath. Don't feed the voice. Don't condemn it. Treat it with kindness. It's just the part of you that's afraid of something new, of doing it wrong, of failing, or looking like an idiot, of being creative, or doing something different. It may even

be frightened of being mindful, of coming into a greater sense of connection with the inner self through drawing. Mostly our critical, fearful voices are there in some skewed way to protect us from a perceived threat – even if that threat doesn't really exist. So go easy on yourself.

• Just let the critical thoughts be there. If you keep getting drawn into them, thinking them all over again, that's ok. This may take some practice, but every time you find yourself thinking them, just come back to the body, back to the breath. Use these as your mindful anchors.

• Sometimes our critical thoughts are accompanied by emotions and feelings in the body. You might notice a tension in your chest or in your hands, or a feeling of sadness or irritation. If you do, then you could just acknowledge these too. Include the physical feedback from the thoughts in your awareness along with hands and breath, but don't feed the voice, don't engage with it, just let it be.

• When you feel that you have come back to a quieter head-space and have successfully acknowledged the thoughts without going on a long, critical, inner ramble, resume your drawing. Allow yourself to become absorbed once again in what you're doing.

GETTING STUCK

◆

Sometimes all we need is a split-second mindful pause to break the flow of the thinking-mind as it gears up for judging and criticising. However, at other times just a brief acknowledgement of the inner-critic might not be sufficient; we may need to pause for longer, or practise pausing regularly.

O UR PATTERNS OF SELF-JUDGEMENT and criticism may have become so deeply ingrained that they've become beliefs we hold about ourselves and about our capacity to draw, or to be creative. As we pause we may feel a strong sense of resistance, tightness or discomfort in our bodies, a veritable whirl of criticism in our heads, even a feeling of sadness or despair. This can be an intense experience, but we shouldn't let it put us off. We're learning to live with our inner critic, and more than any other approach, I have found mindfulness the most helpful thing in moving myself, and others, beyond these creative blocks. Mindfulness practice offers a gentle way to get un-stuck when our thinking-minds have backed us into a tight corner, and it does so through expanding our awareness of our mental patterns.

Having built a sense of ease and familiarity with the 'eyes closed' foundation practices of doodling, mindfulness of breathing and the body, it becomes very easy to notice when

the critical thoughts appear. Quietly, with an inner stillness, we draw, and then we open our eyes and – *ping* – there's a critical thought. It's rather as if we're just encountering the thinking-mind for the first time. And we can really tell the difference, because we've been hanging out in the being-mind for a while, so now we *notice* our thoughts in a very clear way.

The Freedom of Mindfulness

This is the first great gift of mindfulness, to make us aware of our own thinking processes. Here it is, a critical thought, but just for a moment there's a little space to notice it's there, and in that space we have a choice. We can think it, believe it and act accordingly; or make a choice to see it as just a thought, something that's arisen in the mind by habit, but which we don't have to accept as the truth, we don't have to believe, we don't have to act upon.

This is the liberation of *being-mind*, this is the freedom of mindfulness. You don't have to believe the thoughts that say

In spite of everything I shall rise again:
I will take up my pencil, which I have forsaken
in my great discouragement, and I will go
on with my drawing.

VINCENT VAN GOGH (1853–90)
DUTCH POST-IMPRESSIONIST PAINTER

your drawing is rubbish; that making room in your life for creativity is selfish or indulgent; or that you haven't the time. You can pause, for however long it takes, waiting for the ripples of that thought to spread out and reach the shores of your inner self, and when the water is still again, you can continue to draw.

Thoughts are simply habits. Habitual thoughts create neural pathways in the brain. The thoughts we think frequently are like super-highways. If you've got a strong inner critic, then the thoughts associated with it are zipping down pathways in your brain like four-lane motorways. But thanks to something that scientists call neuro-plasticity, we can literally change our minds. Practised over time, mindfulness allows us to interrupt the habitual flow of our critical thoughts, so that gradually those highways in our brain become disused, degrade, turning into overgrown country lanes, single track paths, and finally – we hope – nothing at all.[2] And all the time this is happening, all the time we're allowing those critical thoughts to peter out into nothingness, and we continue with our drawing, we are developing new attitudes, allowing ourselves to discover that in fact it's OK to draw, to be mindful, to connect with ourselves in this way. We change.

Practised over time, mindfulness allows us to interrupt the habitual flow of our critical thoughts

Finding Change on the Page

The simple doodling and mark-making exercises in this chapter form the basis of all mindful drawing activities. They are, if you like, the foundation course. The mindfulness of breathing and body are meditations we can return to again and again. And every time we practise them, they are different; because the self we bring to the page, the mental state we're in, the emotions we're carrying, the day we've had – they are different.

The marks we make during these mindful drawing sessions are likewise testament to the ever-changing nature of our experience – they, too, always vary. This is one of the profound truths that the mindfulness of drawing reveals to us – *every day we're different*. The critical thought passes and a positive one arrives. The sadness of yesterday gives way to the happiness of today. The stressed, distracted mind of the morning is replaced by the calm, sleepy mind of the evening. As we begin to engage with these practices, we become more mindful of the impermanence of our mental and emotional states, even of our physical being (this morning an achy shoulder, tonight no pain at all). This can give us a greater sense of space, of freedom, as we start to recognise – not conceptually, but experientially, through our drawing, through the body – that all things pass. We realise that we are in a process of constant change, as dynamic, energetic and fascinating as the textures and marks of our drawings on the page.

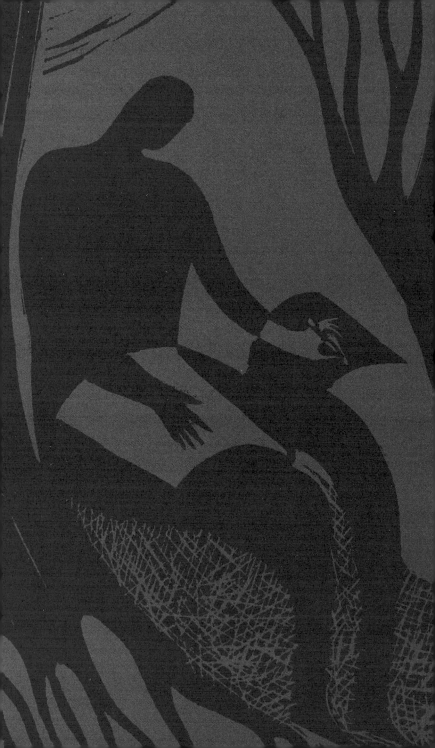

CHAPTER TWO

STILL LIFE

*At the heart of all drawing is the act of
seeing. And seeing, perceiving clearly, is at the heart
of all mindfulness practice too. This book may as well
be called* Mindfulness in Seeing, *so intrinsically are
the two practices linked together. So in this chapter
we'll begin to think about the relationship between
seeing and drawing, which is also a story about subject
and object, about separation, connection and
interconnection.*

LEARNING TO SEE

◆

What if you could experience the world as a child does, everything new, curious and unexpected? What if you could experience the world with the beginner's mind of mindfulness, so that even the most ordinary and the everyday became extraordinary?

M Y FIRST EXPERIENCE OF A MINDFUL DRAWING and seeing exercise happened in my very early twenties. I had just started doing yoga and had had my first experiences of sitting meditation in the class, though this was before I discovered mindfulness practice. All I knew on this particular day was that I'd found a rather intriguing drawing exercise in a book – the title of which I can now no longer remember – and that I was inspired to try it.

It was summer and I was at my parents' house. Standing on the lawn in the back garden, I looked around for a suitable thing to draw. The sky was very blue and I could feel the heat of the sun on my shoulders. *A natural thing*, the book suggested, so I gazed at the familiar trees of my childhood home, the shrubs and perennials in the flower beds, until my eyes came to rest on a fat, luscious, overblown pink rose. I'd draw that, I decided, placing a chair on the lawn by the flowerbed and feeling its legs sink in a little as I settled my weight in it. Above me, a crab apple tree rustled its small, dark green leaves, the unripe nubs of the apples shiny in the sunshine.

The Mindfulness of Seeing

Practise the mindfulness of seeing for several minutes before you ever practise the mindfulness of drawing. Whatever you choose to draw, spend time with it, looking until looking becomes seeing, and you are drawn more closely into relationship with your object.

We can practise this even when we don't intend to draw. Try looking at your house plants – not just giving them a cursory water, but stopping, seeing their leaves, the colours and shades of them, the way they meet stems. Have you ever really looked at your plants, I wonder? Have you ever *seen* them? If you're out and about, take time to stop and see what there is around you. The bark of that small tree you pass every day may have an extraordinary pattern or texture. The scrubby grass growing between the paving stones may be coming into flower. That billboard, may have a dozen fascinating layers of old adverts, faded, weathered, shading into different colours almost like a collage.

Stopping and taking the time to see in this way subtly changes our relationship to the things, people and places around us, and reveals the unexpected, startling beauty that is present everywhere.

And then I looked at the rose. I didn't pick up my pen. I just looked at it. My eyes traced the curves and undulations of the petals, following the intricate lines as they folded inside each other, overlapping, touching and falling open, leading my gaze towards the clasped petals at its very centre. I continued looking at the rose like this for some minutes – as my book instructed; looking, indeed, for a great deal longer than I usually would have looked. Looking, almost to the point of boredom, to the point where my mind wandered off and I had to bring it back to the rose.

Beyond Looking

That summer day I thought I was pretty much 'done' with the rose. I didn't think there was much more I could take in, but I carried on looking anyway. And as I did, everything seemed to shift. I stopped being bored and suddenly noticed something new – gradations in the shades of pink on the petals, paler at the edges, a deeper tone nearer the centre, which I leaned in closer to see better. I stopped looking and started *really* seeing. By which I mean I lost the sense of 'doing an exercise' or even of being a person looking. My sense of self fell away and I was just there with the rose, taking it in in very close detail.

Then I smelt it, burying my nose in its satiny softness, inhaling, filling my nostrils, my mouth, my lungs with the scent of rose. I touched its petals, warm and yielding as skin.

Nobody sees a flower – really –
it is so small it takes time – we haven't
time – and to see takes time, like to have
a friend takes time.

GEORGIA O'KEEFFE (1887–1986)
AMERICAN ARTIST

I traced the lines of them with my fingertip. And all this was part of my seeing, my knowing this one particular, perfectly ordinary, totally unique rose. Only then did I pick up my pencil and put it to the page, doing as the book had instructed me to do, *to draw without looking at the paper*, without checking if my drawing was correct or right or 'good'.

Really Seeing

What happened was a revelation and I'll never forget it. The rose came alive for me on the page in a way no flower had ever done. My pencil made a journey across the sketchbook on my lap, moving, making marks, but I didn't look at them. I was totally immersed in seeing that rose, and the marks I made were just an extension of this act of noticing and relating. The rose unfolded before my eyes, revealing under the continuing closeness of my attention even more aspects of itself, aspects that, of course, my usual cursory glance would never have noted.

DRAWING EXERCISE

THE MINDFULNESS OF SEEING

For this exercise, I'm inviting you to do the same as I did with that rose on that day long ago. You may draw with any medium: pen, pencil or charcoal, but just use a single colour. You may also draw on any surface; smaller sketchbooks are good if you're outside, or a big sheet of paper on a board or table if you're indoors.

Choose an inanimate object to draw. Natural objects, flowers, stones, shells or leaves are always good for this exercise. The textures, colours and shapes that nature creates are generally far more subtle and complex than man-made things – although, having said that, this exercise is wonderful with any object, and will subtly affect how you relate to it, whatever it is.

• Take time to really SEE what it is you have chosen. As I did with the rose, spend some time not just looking, but touching, smelling – exploring it with all your senses, so that you come to know it better.

• Only when you've done this should you decide what side or angle you are going to draw, and whether you wish to place it on a table or hold it in your hand while you are drawing.

• Now start to draw your object. But here's the important thing – DO NOT LOOK AT THE PAGE YOU ARE DRAWING ON, and try not to peek until you finish drawing! Let this drawing be an extension of your seeing, taking you even deeper, even closer.

• You may try this exercise in two different ways. The first time, try drawing without taking your pen or pencil off the page; this is sometimes called 'taking a line for a walk'. It means that you'll have to double back on your-self, retracing where your pen has travelled, moving over the paper repeatedly, and tracing those lines on your object with your eyes too. The second time (with the same or a different object), you can try taking your pen off the page as you draw, but remember, still no peeking at your paper!

• However you draw, allow your eyes to move over your object lightly, taking in its unique nature. Let your pencil move lightly too, following the

movement of your eyes, so that it almost feels as if the eyes and hands are one, and that it is with your gaze that you make marks on the page.

• Keep your hand loose and relaxed. And keep checking in every now and then with your breath and the rest of your body.

• Stay with your object. If you get bored, try paying a little more attention. Spend at least ten minutes with it, drawing and redrawing. The intention is to come closer to the subject of your drawing. This exercise is about seeing and experiencing – not copying. Which is great news, because it means you don't have to worry about what the finished 'product' will look like.

• When you have finally finished drawing, spend some time just looking at your inanimate thing again. Does it still seem the same to you? How has your relationship to it changed?

• When you feel you're finished, take a few moments to sit quietly, sensing the breath, feeling the hands.

• And NOW, if you wish, you can look at the marks you made on the page. Most people find that these drawings possess an amazing aliveness. The lines are loose and expressive and aspects of the object – its form or texture, for example – jump out, in amazing detail and accuracy, even if the drawing as a whole doesn't look exactly like the object it was inspired by.

This exercise is one that can be done over and over again. In classes, it is probably the exercise that most successfully undoes the tight knot of self-doubt or self-criticism many drawers carry with them and is consequently very popular. Many choose to spend the whole day without looking at the page, so liberating do they find it. This is an exercise I return to if I know that I'm not seeing very mindfully and need to come back to what's in front of me.

Drawing without looking at the page is also a great introduction to drawing *and* looking at the page. And at some point, you may like to repeat this exercise – drawing an object first without looking and then, on fresh paper, drawing *and* looking, following the guidelines I'll give you later.

Mindful Collecting

Why not make collecting the objects you're going to draw part of your mindfulness practice? Over the years I have gathered together a box of natural things: seed pods, dried leaves, teasels, shells, stones, which I've found in gardens or on walks. They were all gazed at and lovingly selected because they were pleasing for some reason or other. I love having this box of things, taking it out for drawing classes, sharing them with other people; however I also enjoyed the collecting of the objects, and looking for them became a mindfulness practice in itself.

And it doesn't just have to be natural things; if you love old objects and bric-a-brac, how about a mindful shopping trip to some charity shops to collect interesting things to draw? The bargain or give-away box in these places is always particularly appealing to me, since it contains the over used, slightly worn down and the much-loved. Old toys with chips and bald patches; cups that have been lovingly stuck back together after a fall; or a pair of shoes with lolling tongues and a bulge of leather where a bunion used to be – all can make fantastic things to draw.

And the more I saw, the more there was to draw, and the more I drew, the more beautiful I found this rose, and the more unique it seemed. And the only way I can describe it was that I felt like I was being drawn *into* the rose, closer and closer, until I felt I knew it intimately. It no longer seemed inanimate to me, but was filled with a vibrant living identity. So much so, that years later, I still see it in my mind's eye.

FROM LOOKING
TO SEEING, & BEYOND

So now we've had some practice at mindful seeing, let's have a think about the differences there might be between seeing and looking. It might help to start by considering what is actually happening when we gaze at something.

WHEN WE LOOK AT A ROSE, for example, electrical signals travel via the optic nerves to the thalamus, which sends information to the visual cortex, which processes it, puts it all together and gives us a complete picture of the flower we're looking at. From a mindfulness perspective, looking happens with the eyes and brain only. There's nothing mindful about it, it's purely 'mechanical'. Seeing something, however, requires awareness. It requires us to let go of the thinking-mind and just be present in body and mind, with what our eyes are resting on.

When we see in the way I did all those years ago when I was looking at that rose, we focus on our direct experience, by which I mean the immediate sensations and perceptions in an encounter or experience. We are perceiving and seeing, rather than thinking. In focusing on these direct experiences and becoming absorbed, the thinking-mind is quietened and we can move into a relationship with the 'other', which is defined by an open awareness of it. This awareness isn't just a mechanical process of the eyes and brain, but an openness and perception that belongs to the whole of our body and mind. Here, we start to experience both the sense of simply being we explored through the mindful doodling, body and breath practices in the previous chapter; but also something else – that opening to the world I talked about earlier.

Coming into Relationship

What is interesting is that when we see in this present, feeling, being way, our sense of object and subject begins to break down. The clear delineation between it and us starts to loosen. Instead, we experience a greater sense of closeness and connection to what we're looking at. This is because when we're practising the mindfulness of seeing and drawing, the *thing* we are drawing is *held in the space of our awareness* along with our thoughts, feelings and experiences as the drawer. In these moments we are no longer separate, we are unified through awareness, and this changes how we relate to things.

Naming It

The difference between looking and seeing could also be defined as the difference between 'brain' and 'mind'. The 'brain', as I write of it here, is the seat of the thinking-mind. The brain contains grey-matter, synapses and neural pathways, all firing off electrical impulses that somehow translate into thoughts. The brain is a machine, just as the eye is a machine, and an incredibly complex and extraordinary one it is too.

However when I write of 'mind', I am talking about that broader field of perception and awareness I call the being-mind. The mind, in this sense, is quite a mysterious, hard-to-pin-down thing. As we begin to practise mindfulness and become used to moving into and resting in that state of being, we start to discover that 'mind' seems to include aspects of perception and presence that we experience through the physical body; it may incorporate a heart or feeling sense; as well as aspects of 'gut-instinct' or intuition. We might even call it the body-mind.

Next time you find yourself in a calm, aware state, gently ask yourself where your sense of mind is located. I'd be willing to bet it isn't confined to the skull-box in which you keep your brain.

What I discovered that day when drawing a rose is that when we're drawing and seeing with awareness, we draw closer, and come into relationship with the thing we are drawing. In truth, drawing is all about relationship, because it requires us to build connections with the world around us, to get to know it better and deeper through the process happening on the page. When we draw something, the nature of that object, place or person can communicate itself to us and we can reciprocate and reply – show that we have noticed – through the marks we make as we draw. What we are starting, in fact, is a dialogue, and talking is how relationships are formed.

In his beautiful book *The Spell of the Sensuous,* the philosopher and phenomenologist David Abram writes about this reciprocity as a thing of the body, of hand and eye, not just the brain. 'My hand,' he writes, 'is able to touch things only because my hand itself is a touchable thing. Similarly, the eyes, with which I see things, are themselves visible.' He continues: 'To touch the coarse skin of a tree is thus, at the same time, to experience one's own tactility, to feel oneself touched *by* the tree. And to see the world is also, at the same time, to experience oneself as visible, to feel oneself seen.'[3]

When we are drawing and seeing mindfully, then, we are encountering the world in an intimate way that we may never experience anywhere else, or in quite the same manner. The connection we form with what we are seeing, what we are

drawing, and where we are drawing goes beyond the intellectual, beyond words and language, or even marks on a page. It even goes beyond the thinking-mind. This is the relationship of two bodies in space, an intuitive relationship of the spirit, where we begin to sense the nature of things, their 'is-ness', their 'being-ness'. And when this happens, we can simply be with them in our completeness too. More than that, we start to lose our sense of subject – us in here, and object – it out there.

Insight & Calm Abiding

In resting in the thing we're drawing, in abiding with it, steadily, calmly, we move into that state of simply being where the nature of ourselves, the world, and our reality can be revealed to us. Or we may experience new ideas and perceptions of what this reality may be. This gradual realisation about the nature of things is called *vipassana,* which means *insight* in Pali, the language of the early Buddhist writings. The process of focus, absorption, and of simply being, with which you're becoming familiar, is also called *samatha* in Pali, which can be translated as 'calm abiding'. Calm abiding and then insight. Where there is samatha, then vipassana generally follows, given a little time.

The mindfulness of drawing and seeing, like all good mindfulness practices, has an extraordinary capacity for facilitating these moments of both calm abiding and insight. And once

we encounter them, they can change our relationship to ourselves, and the world, for ever. What if, as our being-mind suggests, we are not as separate as we think? What if the world touches us, converses with us more deeply when we draw, not because it's coming closer, but because there was never any distance to begin with? What if the 'I' that the thinking-mind identifies with is actually just a small part of a greater awareness that includes all things? What if there isn't really an 'us' and 'it', subject and object, at all?

THE DIFFERENCE
BETWEEN IDEA & EXPERIENCE

In the gap that calm abiding creates between our experience and our ideas about our experience, insight or vipassana can happen. When we're just drawing, just seeing, simply being, we move out of the thinking-mind and into the being-mind, into the sensing body, into direct experience.

IT'S VERY DIFFERENT TO BE JUST DRAWING, absorbed in the present moment, in the arc of our hand across the page, experiencing a peaceful stillness as we sketch, than it is to be drawing with the thinking-mind giving us a commentary, analysing, conceptualising, judging and comparing. *Hey, I'm drawing, right now. Look, this is drawing. I'm quite good at it. I'm drawing with that charcoal I bought from the art shop on the high*

*street. Charcoal is made from burnt willow. When I was at school,
I climbed a willow tree and fell out of it. Look, there's the little scar
on my wrist still. But ooops, no – drawing, drawing, I'm drawing.
Hmmmmm, I'm not very good at it. That's a mark. There's another
one. Is it time for lunch yet?*

For every experience we have, our thinking-mind has a
concept, an explanation, and a commentary. It jumps around
from one association to the other, and our task when we're
practising mindfulness is just to notice that that's what it's
doing. This ceaseless activity of the brain is sometimes called
'monkey-mind'. I like this metaphor; I see my thinking-mind
with a long prehensile tail, fluffy ears, wide grinning monkey
teeth in a monkey smile, long arms for swinging from
branches, one branch to another to another, one idea to
another to another, on and on, never stopping. Always chat-
tering. The focus of our mindful drawing draws us into
absorption and flow and helps to silence our monkey-minds
wonderfully well, perhaps especially because it's a non-verbal
activity. As the chattering of our thinking-mind lessens,
and those calm, clear spaces of abiding and drawing happen,

Art enables us to find ourselves
and lose ourselves at the same time.

THOMAS MERTON (1915–68)
AMERICAN WRITER AND MYSTIC

we may also start to become aware of what a difference there is between the experience of something and the idea of it.

For example, we can experience the bright intensity of a hot summer's day through our whole bodies, but it is very hard to do so without our minds labelling things – heat, sun, yellow, haze, summer, sky. These are all concepts, ideas we attribute to the experience. There's a subtle layer of thinking interpenetrating our experience at every moment, which we're so accustomed to that we may be unaware it's happening. We may be seeing the undulations, shading, scent and delicacy of a rose, but we are also labelling and categorising it as we look at it and draw: petal, stamen, perfume, charcoal, paper, movement, hand, holding, pen. We may also be remembering other encounters with roses. We may recall useless bits of information and facts about roses, too.

Experiencing Life, Not Thinking It

This is all normal. It's what the thinking-mind is meant to do, and it's very good at it. This capacity for concept and language is incredibly useful and we wouldn't be human without it. But there is another way of experiencing the world, of experiencing our drawing. As we move into awareness, into that open state of receptivity and sensitivity that embraces everything, we are able to glimpse the world without concepts, without ideas, we're able to begin to experience our *actual experience* without as much mediation from the thinking-mind.

This has implications, too, for what and how we draw. Just imagine for a moment that, instead of looking at a form and naming it *tree*, and then subcategorising – branch, twig, leaf, roots, memory of trees, feelings about trees; instead of making *tree* an object, a thing in your mind and a thing in the world, you just experienced what was there. Breathing, open, aware, noticing your brain's tendency to categorise, you just kept on letting all that go, letting it go. What then would your experience be? How would it change how you related to the tree? Perhaps it would make you see, perceive and experience the form before you entirely differently. Perhaps it would become not an object and you the subjective viewer, but instead, another centre of experience: leaf blow, wind shiver, root squirm, insect crawl. Perhaps it would become something formless, changing, unfixed that you couldn't even begin to stamp a label on.

Our relationship to the world and the things of the world can change when we are practising mindfulness. When we pick up a pencil and just draw, all our old ideas of object and subject, separation and connection may be altered for ever.

◆

The painter has the
Universe in his mind and hands.

LEONARDO DA VINCI (1452–1519)
ITALIAN ARTIST

◆

DRAWING EXERCISE

DIRECT EXPERIENCING

This drawing meditation is in three parts, and serves as a practical example of the difference between the conceptual and experiential relationship that can be unlocked when we draw. You can draw in any medium, and on any surface. The first part of the meditation should only take a couple of minutes; the second part five to ten minutes; and the third part you may do for as long as you wish, but for at least the same amount of time as Part Two.

Part One

• Look at your hand, the hand you don't draw with, your non-dominant hand. As you look at it, notice how your mind immediately starts naming: skin, lines, knuckles, fingers, etc. Accentuate this natural tendency; label and name all the parts of your hands.

• You may have particular memories or emotions associated with this hand. For example, when I first did this, I noted that my hand was like my grandmother's had been. I also found myself judging. I get eczema on my hands, so they're always a bit dry and wrinkly. I used to get called 'Granny-hands' at school because of this. See what associations you have with your hand.

• What you're having here is a conceptual relationship to your hand. Even if you're remembering something you've done with your hands, that's still a concept, since you are recapturing a moment from the past, and this past is now just a notion in your head.

• There we have it, your 'idea' of hand.

Part Two

• Now sit quietly with your non-drawing hand in your lap. Close your eyes. Tune in to your hand, to the sensations in it. What can you actually *feel*? Heat, coolness? Tension, relaxation? Are some areas of the hand more full of sensation than others? Do some parts feel larger or smaller? Is there any sense of tingling or energy in the hand, perhaps in the palm or fingers?

• Try waving your hand and moving it. Feel the waft of air against skin, the twitch of tendons.

• What you're having here is a direct experience of your hand. Of course, you may notice little labels slipping in; just let them go, come more closely into the actual sensations and see if you can let the names for things pass.

• When you feel ready, pick up a pencil or pen in your drawing hand, *and with your eyes closed*, I'd like you to just start transcribing the feelings and sensations in your non-drawing hand onto the page. This is a little like the mindfulness of the breath exercise we did in the previous chapter. What marks can you make to indicate the different sensations? Make them up. Make it abstract.

• Trace a connection on the page with what you are experiencing in your hand. Just keep moving backwards and forwards with your attention between sensation and drawing, checking in. Let your drawing hand move as instinctively, without thought and predetermination, as possible.

• When you've finished, sit for a few quiet moments noticing the sensations in both hands, and then open your eyes. I find these drawings are always surprising and rather beautiful when we finally look at them.

Part Three

• Now look at that non-drawing hand again. See if the previous activity has altered your response to it.

• Take up your pen or pencil again and draw this hand. *Draw without look-ing at the page.*

• Are you able to draw without thinking of labels like fingers, or knuckles? If you notice these names in your mind, that's fine. Just note they're there and come back to seeing, just drawing shapes, surfaces, form and texture.

• Continue for as long as you like. Conclude in your usual mindful way, with a pause.

DRAWING EXERCISE

STILL LIFE

Again, you may use anything you like to draw with, working only in black or in colour, and on any type or size of paper. I'll give you a few pointers on drawing in the exercise below, but the purpose of this book isn't to teach you drawing techniques, it's about the experience of drawing, the experience of mindfulness and seeing. There are many, many excellent books on drawing technique out there, so if you feel you need to – go find one! In the meantime, if you've never drawn before, or only a little, my suggestions might be helpful.

● Start your drawing process in the same way as before, by selecting an object or several objects to draw and spending some time with them, until you feel that you're really starting to see them.

● You may like to mindfully arrange your things too, creating a grouping that emerges out of the calm abiding of seeing and handling them. It is in this quiet time before we even start to draw them that things start to reveal their secrets.

● Starting from the outside, the outline or silhouette of a thing, isn't always the easiest way to draw. Experiment, by all means, but I suggest you try drawing from the inside of an object towards its periphery. This makes it easier to evaluate the relationship between its different parts and adjust them as you draw, rather than having to cram them into the narrow confines of an outline you set down at the beginning.

● It can help to work between interior and silhouette, jotting in a few faint marks, as you plot out the dimensions and relationships that create your object's form.

● Remember a line can always be moved or removed. Drawings are experiments with marks and space and form. Enjoy them. Use the drawing process as an experiment in getting to know a thing, in seeing and coming into relationship with it, rather than an exercise in getting it right and copying it perfectly.

• Feel free to work only in line at first, but later on, either in this drawing or another, you may wish to give your object some three-dimensionality. If you do, look to the gradations of light and shade. Squinting can be good for this, as it removes the object's sharp details and helps us to see the shadows better. Shading in the shadow will start to give your drawing a three-dimensional appearance.

• Take a mindful pause now and then. Breathe. Feel your hands. Spend a little time quietly seeing your object. Then resume your drawing.

• If you notice your inner critic piping up, this would be the perfect time to take that mindful pause.

• Keep on looking, keep on seeing. Up and down with your eyes between object and page. Measure distances, not just visually, but also with a pencil held out at arm's length, comparing, adjusting your lines.

• Look, too, at the spaces between things. These negative spaces are really important. It's often easier to draw the negative spaces; for example, the shape of the empty space between the handle and body of a jug; rather than focusing on the contours of the solid china of the handle and body. It's all about how you choose to see!

• Move between drawing and measuring the negative and positive spaces, in order to keep the dimensions of your object on the page more accurate. *You should be looking at your object as often as you look at the page.*

• Continue until you feel you can see no more, or until you feel your drawing is as complete as it can be today. When you feel you're finished, take a few moments to sit quietly, sensing the breath, feeling the hands.

THE SECRET LIFE OF THINGS

◆

I love THINGS. *Objects are little windows through which we can glimpse the lives of the people who cherish them. They tell stories, hold secret histories or memories, showing the wear and tear of use or the influence of the elements.*

I REMEMBER FINDING TRADITIONAL 'STILL LIFE' rather boring at school. I'm sure I must have groaned inwardly as the art teacher plunked down an orange and a vase for us to draw. It all seemed so static and lifeless. The depressing (or so I thought) vanitas paintings of the medieval era, with their pre-occupation with death and decay, probably also contributed to my adolescent thought that still life was a dismal subject.

At that time I hadn't discovered the mindfulness of seeing and drawing, and so it wasn't until later, as I headed to art school, that my fascination with things really began to emerge. I once did a whole art project around mannequins. I spent much of a one-month stint in New York – New York, one of the most vibrant, extraordinary cities on the planet, where all of life can be found on the streets – holed up in flea stores, making visual records of the odd things and bric-a-brac stored in them. Things are a bit of a preoccupation – and so I'd like to invite you, too, to discover the secret life of things through your drawing. And now that you've been practising the art of mindful drawing and are starting to get a feel for the differ-

ence between looking and seeing, between analysing and experiencing, you'll probably be able to hear their whispers, their tales of experience pretty well.

Unsatisfactoriness

I hope you find an enormous amount of creative satisfaction, enjoyment and relaxation when you draw. However, like all things in life, drawing too contains elements that can seem unsatisfactory, and you may notice this when you reflect on your experience.

So how did you get on? In what ways was drawing with your eyes open different from drawing with your eyes closed? To what extent were you able to stay present with your drawing and with seeing? To what extent did your thinking-mind get involved? Or your inner critic? Recognising our patterns is a good thing. It helps us nip habits of self-criticism or self-doubt in the bud mindfully.

But what if the thing you noticed was a general sense of your drawing session being unsatisfactory. Perhaps your charcoal crumbled just at the wrong moment, or you couldn't find a pencil sharpener. Maybe your paper tore, or you ran out entirely. Or your seat was uncomfortable. Or the telephone kept ringing, and the kids wouldn't leave you alone. Or you got bored, or fed up, or over-ambitious. Or you felt you weren't being mindful at all. Unsatisfactory. Unsatisfactory.

Recognising *Dukkha*

Dukkha is a word used for this experience of the unsatisfactory in life. The Pali word is often translated as meaning the pervading, underlying unsatisfactoriness of our existence. In Buddhist philosophy, dukkha is said to be the experience of every living thing in our universe. We're born, we age, and then we die. We try to hold on to things, but we cannot, they change, they disappear. We try to pin down that lovely rose on the page, capture its essence, but our drawing doesn't satisfy us at all. It doesn't get it right. And when we go back the next day, to try again, the petals have fallen, the rose of yesterday has disappeared.

A sense of impermanence and unsatisfactoriness may sometimes subtly underlie even good or happy moments, because we know they will soon end. But recognising the existence of dukkha, now that's a liberation. This recognition is so important, so powerful, in fact, that it forms the first of what are called in Buddhist philosophy the 'four noble truths'. These truths, if reflected on deeply, are said to lead a person to freedom from the endless cycle of dukkha.

Whatever you may think of this philosophy, there's no doubt that noticing unsatisfactoriness when it crops up in our drawing practice is incredibly helpful. If we recognise the dukkha in our experience while it's there, while we're experiencing it, then we have the opportunity to bring some mindfulness to it. This is where we can take our mindful

pause. We can notice the unsatisfactoriness of things and make a little peace with it, breathe around it, and let it go a little. If our three-year-old is whining and wants some attention, or if our hour of precious drawing time has suddenly been eaten up by a work emergency, or if our trip to the local park to draw a blossom tree is interrupted by a heavy April shower, or it seems like our drawings are getting 'worse' not better – then just breathing and acknowledging the feeling of unsatisfactoriness will help us get less hung up on it. It creates a little space and perspective.

Moving Beyond Unsatisfactoriness
And if, as we're taking that mindful pause, we notice that our experience of dukkha actually comes from our *desperately wanting things to be different* or indeed, *desperately wanting them to stay the same* – then we're starting to discover the essence of the second noble truth: that it's our desire for things to be a certain way, our attachment to life running to our own internal checklist for happiness, that causes so much of our sense of unsatisfactoriness.

Because we wanted our three-year-old to stay engrossed in their game and not bother us; because after a manic week at work we were desperately looking forward to an hour of drawing; because that blossom was gorgeous and it's gone; because we've been drawing regularly for a year and we thought we'd at least be able to draw a goddamn tree by now.

It's this frustrated desire for things to be different that can cause so much of our stress and anxiety. But once we've mindfully noticed dukkha, and the accompanying not wanting things to be the way they are, we can make a choice to relax and open to our being-mind, to calm abiding. Our being-mind just holds all of our experience in awareness – the torn paper, the scratchy pencil, the clumsily drawn leaf, the aching neck, the self-doubt and self-criticism too. When we can relax into simply being despite the dukkha, our sense of tension and of unsatisfactoriness often diminishes. It may even disappear completely.

The mindfulness of drawing offers a wonderful opportunity to work practically and at an achievable level with unsatisfactoriness, and to start to loosen our attachment to particular outcomes. And once we are adept at handling it in our drawing practice, it becomes much easier to handle it mindfully in other areas of our lives, too. It takes some practice, some familiarity with moving out of thinking and into being, but everyone can do it. And as we do it, we discover the heart of the third noble truth, which is that liberation *is* possible, that we can let go of needing things to be a certain way when we draw, and just draw.[4]

> *We can let go of needing things to be a certain way when we draw, and just draw*

Looking Up from the Page

If we're not careful it's very easy – once we start the actual drawing process – to lapse into not really looking at all. There we are happily getting on with our drawing, pencil skimming across the paper, perhaps a little frown of concentration on our face, perhaps feeling very contented with it all, but we've forgotten to look at the thing we're drawing for at least two or three minutes. If you're just looking at the page as you draw, then you're not really seeing, you're just remembering what you saw.

Really seeing, or even just really properly looking, is everything in drawing. Paying attention. Our eyes need to move constantly between our 'rose' and our drawing, noticing, taking it in. True-to-life drawings come from unlearning the habit of assumption, where we glance quickly and make up the rest on the page. True-to-life drawings come from developing the habit of looking, seeing and drawing simultaneously.

CHAPTER THREE

LANDSCAPES
& CITYSCAPES

*A drawing is a meeting point in time and
space; what we draw, the space it occupies, and
the time it took to draw it are all present on the page.
Landscapes and cityscapes are also meeting points in
time and space. This field, that line of rooftops, remain
present but alter through the seasons, through day and
night. In cities, we encounter the passing of time
and witness how everything is constantly changing.
In landscapes, we encounter silence, the stillness
of the non-human world, which draws us
effortlessly into greater mindfulness.*

Drawing in Nature

When I go on meditation retreat, I like to choose somewhere wild; the presence of nature helps me to become less distracted and more present in myself. The remote locations provide a strong contrast to my daily urban life, and remind me about the still, alert presence of the land.

As I write this, I'm reminded of a line from a poem by the Irish poet Derek Mahon, called 'The Mayo Tao'. 'The mountain paces me in a snow-lit silence,'[5] he says, describing a walk to the shop four miles away. I love this idea of the mountain keeping pace with him. It describes perfectly the sense of companionship I find in the presence of nature, and also touches on one of the key aspects of this mindful relationship – that it is silent, wordless.

Heading into the Wilds

My last retreat was in the Highlands of Scotland. Travelling from my home on the south coast of England, I took a train. And then I took another train. And then another. And then a bus. And another. And then finally, eleven hours later, I boarded a local minibus, which wound along country roads that got narrower and narrower, the mountains rising up on either side. A feathery, dark green canopy of forest stretched out along the valleys and the banks of the lochs.

Touching Silence

How much of your day is spent with background noise, the radio, the TV, the ring of your mobile phone, constant text and email alerts, the thrum of the city? Sometimes this background noise is so persistent that we almost cease to notice it, and it's only when we are somewhere particularly peaceful – in the countryside, for example, without mobile phone reception – that we actually realise that silence is something we've been unknowingly needing or even craving. *Ah*, we say, *how peaceful it is*. And we sigh, stretch our bodies a little, remark how we really should do this more often.

Taking time to turn down the volume on our modern lives on a regular basis makes space for more mindfulness and silent presence, and we don't have to go on retreat to experience this. You could make some quiet time for yourself every week, or even every day. Try drawing in silence, without music on for company. Try turning your phone off for an hour. See what it's like to come home and not turn the TV, the stereo or the radio on as soon as you're in the door. Experiment with eating in silence. Discover what silence can do for you.

Nature started to work its magic swiftly. Gradually, the excited getting-to-know-you chatter of myself and the other retreatants faded away as we looked out of the windows. Gradually, too, the bars of connectivity on our mobile phones dwindled as we lost reception. Arriving at the retreat centre, we stood on the lawn, looking out at the dark, still loch below us, the hunch of the mountain. By the next day, I was more than ready to go into the complete silence of not speaking for the rest of the week.

We meditated for many hours every day on this retreat, alternating between periods of sitting meditation and then of walking meditation, looping around the lawn, gazing at the waters of the loch, the trees, the sky, feeling the sun on our faces, and quite often – this being the Highlands – the soft, cool drizzle of rain. And all the time, the silent presence of the natural world around me, and the silence I kept with others and with myself, worked deeper and deeper on me.

Mindfulness & the Natural World

I do, to some extent, find silence in my daily life. Certainly it is there in my morning meditations, although not so fully, since the traffic trundles by on the road outside my home, somewhere there are roadworks, or a car alarm wails. But in nature, I come into contact with a more ancient, much quieter world. In nature, if I'm willing to go off-road and offline for a while, where there are no adverts, text messages, emails,

or conversation, then I find the mountains, the waters, the woods – keeping pace with me, silently.

In this way, nature can truly be called mindfulness' friend, because it effortlessly brings us into a greater sense of still presence and inner quietness. Certainly meditation in such beautiful, natural surroundings holds an extra peace and calmness. This is something explored by Claire Thompson in her book *Mindfulness & the Natural World*. 'Some places,' she writes, 'have gifted me with a glimpse of universal stillness where the chattering mind has no place at all.'[6] This has undoubtedly been my experience too. However, I've often found that the natural world's lessons in mindfulness can be absorbed more fully, that I'm more likely to listen to them for longer, if instead of just walking or sitting in nature, I draw.

Only Quietness & Stillness

On my Highland retreat we had a period of free time every afternoon, and I would head off in my walking boots with a little sketchbook and a pen tucked in the pocket of my water-proof jacket. On my first day I sat by the loch for a long time, just sitting, taking it in, but still my mind wandered, I wasn't always fully *there*. But when I picked up my pen and began drawing a small willow tree overhanging the water, then I was present, then I was truly *there*, then I noticed the sparkle of gold in the brown peaty waters, the shiver of wind on the long silvery underside of the leaves, the scudding of clouds

Pure Awareness

The immanence of nature draws out a sense of transcendence in even the most earthbound of us, and for many it has a spiritual aspect that goes beyond words or theologies. It grounds us in our own being, and with the energy and atmosphere of the natural world.

When we're drawing in nature, it's easier to move into that state of simply being. We are just *there* with the calmness and stillness of the natural world, and consequently become even more aware of the reach of our awareness. Absorbed in our drawing as we may be, we still have a sense of the landscape around us, of our hand moving over the page. We are totally involved in the activity and place and yet at the same time part of us – that spacious, open part of us – is aware, and we know it.

See if you can be mindful of these moments of pure awareness, of awareness being aware of itself. You may even notice that the tree above you, the river in the valley, the birdsong, the paper, the feel of your pencil, your peace and happiness – all seem contained within this awareness, and that it is vaster than you had previously imagined. One day you may even have a sense that without this awareness, these things wouldn't exist at all.

How much real delight have I had with the
study of landscape this summer! Either I am myself
improved in the art of seeing nature ... or nature has
unveiled her beauties to me less fastidiously. Perhaps
there is something of both, so we will
divide the compliment.[7]

JOHN CONSTABLE (1776–1837)
BRITISH PAINTER

reflecting on the loch's surface. Another day I drew on a post-
card for a friend, wiping rain from the paper's surface, and
from my face. I certainly wouldn't have sat out there that long
normally, not in that weather, but in drawing, I stopped resist-
ing the wetness, I became absorbed in the low hang of clouds,
the bruised blue look of the mountains, the breath of mist
hanging over the water. The drip of
water on the card, the blurring of my *I found a waterfall.*
ink, just added another dimension to *I sat and drew it,*
the drawing taking shape on the page. *drawn effortlessly*
Another day I climbed the mountain *into stillness*
for a while, following the rush and
tumble of a small river. I found a waterfall. I sat and drew it,
drawn effortlessly into stillness, as the shifting light gradually
revealed to me the textures of fern and moss on the slippery
stones. No words at any point. Only quietness and stillness.

DRAWING EXERCISE

LANDSCAPE DRAWING

The following drawing exercise will offer some thoughts and guidelines on drawing landscapes. You may draw on any surface and with any medium, in monochrome or in colour. There is no set time for these exercises, either – just stay with your landscape for as long as the conversation lasts. But remember to start with a little mindfulness of breath and hands, to take some mindful pauses during your drawing, and to finish with some time with the breath, the sensations in your hands and your experience at the end of them.

- Like all mindful drawing, drawing landscapes needs to start with seeing. So find a spot in nature that appeals to you and take some time to sit and see it.
- Gaze around you with an open, spacious attitude. Allow yourself to take in not just what you see, but also what you hear, smell, sense, feel.
- Don't zoom in on details just yet. Don't start analysing what you're going to draw or the composition of your drawing either. Let this natural space come to you. Let what is unique and beautiful about it today be revealed to you, rather than searching for it.
- As you allow yourself to connect with the natural world in this way, waiting, listening, some aspect of it will usually start to impress itself upon you. You might notice, gradually, the patterns made by branches in the woods ahead, or the undulating outline of the hills. It may be that you are drawn to the texture of grasses and earth in a ploughed field, or the softness of the light that seems to blur edges. If you're in the city, it might be a row of television aerials on the rooftops, or the lines of railings along the park.
- Once you've found something to draw – or perhaps I should say, once it's found you – there are two ways you can approach your drawing.

Drawing Details
Sometimes drawing a whole scene, a whole landscape, can seem intimidating – or we may feel we just don't have the time. Drawing details – smaller aspects of the wider scene – can then be a really pleasing and useful approach.

- If it was the patterns of branches that spoke to you, for example, just draw those patterns. Don't worry about connecting them up to the hills beyond or the field in the foreground. Likewise, the textures in that ploughed field – just draw them; make these smaller things your focus.

- You might end up doing three or four of these smaller drawings on one page. Each one is a little meditation, a short conversation. Or a long one – sometimes I can get drawn into these 'details' for a very long time.

- These small drawing meditations may be your way of drawing landscapes, and if they are, you'll get just as much benefit and enjoyment from them as from drawing a wider scene. However, another word for them might be 'studies' – studies being the drawings one does in preparation for a larger drawing.

- Of course, everything we do in our mindful drawing is *the thing itself,* not preparation for it. We're drawing for the enjoyment of it, to be mindful, to be present, to come into a great sense of connection with and awareness of ourselves and what we're drawing. Nevertheless, if you wish to develop your landscape drawing, you may want to move on to drawing whole scenes and use these smaller 'studies' to help you do so.

The Bigger Picture

Even when drawing a wider landscape, starting with the patterns, textures and forms that jumped out at you in your sitting and seeing phase can be very useful. Not only can they give you a starting point for your drawing, but they often provide interesting areas of focus within a larger composition. If your eye was drawn to it, then probably it will make a good focal point for your drawing, too.

- With faint lines, try sketching out the relative positions of the things in your landscape, getting the proportions and placement of the key elements right. Think about how you might use those areas of special focus to hold the drawing together.

- Start in the middle of the page and work outwards as you did when drawing still life.

• I suggest you do an online search on the Rule of Thirds – a simple approach to composition that's been used by artists over hundreds of years, and which arranges key elements along vertical and horizontal lines.

• Also, look closely at distance in your drawing – in other words, what's in the foreground (closest), middle ground, and background (usually distant horizons, mountains, the sky). Balancing these areas will help give your drawing a sense of perspective.

• Draw lightly – by which I mean, don't get too serious. Keep that sense of openness to what's before you, and make your drawing a conversation with what's there, a way of connecting with it more profoundly. The experience is still more important than any finished or completed drawing.

• If, at the end of your time drawing, you feel you see more, have found greater stillness, and are more aware of your own relationship to the landscape you're in, your own connection to it, then your drawing has been a worthwhile experience.

I draw from nature, although on completely

new terms. For me, nature is not a landscape,

but the dynamism of visual forces –

an event rather than an appearance.[8]

BRIDGET RILEY (BORN 1931)
BRITISH PAINTER

Re-imagining Our Relationship to Time

Imagine, for a moment, your life without rushing, without being busy, without getting from A to B and then to Z. Imagine what it would be like always to have enough time, time to spare, time to breathe, time to see, experience, be. Imagine time slowing down, so that you're unaware of it passing. Imagine timelessness, a pause in the spinning of the world, where a few minutes might feel like an hour, or an hour like a few minutes.

Sounds kind of heavenly, doesn't it? And yet this spacious, timeless existence is available to us, we can dwell in it every time we pick up a pencil. This is what it is like to draw. This is the mindfulness of drawing. When we are in that mindful now, really and truly in it, when we are able to quieten the thinking-mind and come into being, then there is no past, no future, nor even a present. Those three words – past, present, future – become just language we use to conceptualise time as an idea. When we're in the now, just drawing, or just sitting, we begin to create a new relationship with time based on experience alone.

If you are interested in exploring the path to awareness that the mindfulness of drawing offers, then drawing landscapes will definitely enrich your practice. And the great thing is that we can go on a drawing retreat whenever we want, and it doesn't have to take eleven hours to find a place to draw! Even those of us who live in the heart of busy towns and cities can dip into the silent presence of nature wherever there is a park or a garden.

A Relationship in Time

It takes time to create a drawing. Unlike a photograph, which is captured in an instant, a drawing evolves, it's a process that happens in real time and can't be rushed. You cannot fast-forward to the end of a drawing, snap your fingers and it's done.

For as long as it takes to draw a landscape, we are with the landscape and our sketching of it. When we are drawing, we are with ourselves for the duration, too – our breathing, seeing, sensing body. As such, drawing is the perfect antidote to our increasingly high-speed, high-tech world. It requires us to pause, to slow down, to notice and, very importantly, to enjoy the present moment.

When we pause like this in our mindful drawing, our complete attention is on what we draw, its lines, textures, colours and form. We are also aware of our hand moving over the

page as we sketch, the warm texture of the paper against our skin, the feel of the charcoal between our fingers. Our mind flows with the activity with no sense of urgency, of needing to be done, finished, and moving on to the next thing. This is why, as I discussed earlier, drawing is not only a conversation but also the start of a new relationship to things. What I'd like to suggest here is that it is – potentially – the start of a new relationship to time, too. Rather than quick consumption and striving, we are invited to relax and just be in the moment, which allows us to connect deeply with the spaces we inhabit when we draw. This attitude is especially helpful if we are interested in drawing landscapes.

Rediscovering the Familiar

When we're practising the mindfulness of drawing, we can pause. We're not rushing to the end, or to meet a deadline. We have nowhere to be – but here, right now. And whether here is a familiar place or a new one, this mindful pause changes our experience of it in subtle but profound ways.

One particular drawing experience still stands out for me, as an example of how the mindfulness of drawing changes our relationship to time, and to familiar things and places. I was in rural Wales, revisiting the family home I'd known for many years during my childhood. This cottage sat on the side of a hill, overlooking a valley with a forest beyond. It was a landscape deeply reassuring in its familiarity. Every field,

hedgerow and gate held vivid memories. Here, where the track dipped down, our family car got stuck, and we had to be towed by the local farmer. Here, my little brother tried to open a gate, and went swinging into the air as it opened, legs dangling, red wellington-booted feet kicking. Here, a hedgerow laid by old Jack Roberts; I watched him work, and he paused every now and then to grin at me, and – if I was very lucky – take out his false teeth and show me his gums. Here, another gate – what we called 'Mum's Spot', which she stood at in the evenings, looking out over the valley; the same gate that my little brother and I climbed over, heading for a gully of trees where we played games and built camps all day.

Everywhere I turned, memories, everywhere familiar scenes and landscapes. The dips and hollows of the fields, the tilt of the valley, the way the sun clipped the coniferous trees on the far hill as it went down; I knew them so well they were inscribed into my brain, patterns etched on my retinas for ever. I didn't even need to be there to look at them. I only had to shut my eyes. And yet here I was with sketchbook in hand, visiting again for a few days for what was to be the last time. I had no firm idea of making a visual record – there were photographs enough in the attic back in London for that. I only had the sense of wanting to sit down quietly for a while, to come into that timeless space that drawing put me in, to breathe a little and be with this place I loved so well and which I would soon be leaving.

Drawing the Old Gate

Looking back now, I think part of me did want to capture it, but to draw all of it probably seemed too much – how could I possibly hope to capture so many years of connection with this place in a few lines, and in so little time? I do remember feeling at a bit of a loss to know where to start. In the end, I just sat down by 'Mum's Spot', and picking out one detail that seemed manageable, I began to draw the old gate.

I drew with pen and ink, on watercolour paper. I know this because the drawing I did then – filled with a wash of water-colour later – still hangs on the wall in my parents' home. And I know I sat on the ground, not just from the point of view in that drawing, but also because I can remember seeing the fields and trees and hills of my childhood through the bars of the gate. However, unlike my experience with the rose, I remember nothing else of the drawing process.

So what do I remember? Not drawing, but really seeing something that I'd leaned on, climbed over, thrown windfalls at, scratched the hairy sides of bullocks through, in a com-pletely new way, because this time, I wasn't just passing through. I remember something of the texture of the weath-ered, rotting wood; I remember the many different kinds of mosses and lichen that were growing on it; the way it listed heavily on its old hinges, the end sinking into the earth. I remember the view of the field through it, the light low, catching the dry grasses, starting to turn them pale gold; the

dark buffer of green trees in the gully beyond. Time slowed. Someone, somewhere, pushed the pause button. I was *there* – fully and totally present. A photograph would have delayed me only a moment. But drawing, drawing fixed me on the spot. Drawing gave me time. Drawing, I would argue, altered time, or at least my perception of it, so that in that moment by moment sharing of space with that old gate, I was able to enter into the experience of it deeply – and say goodbye.

Encountering Timelessness

When I got up from my drawing on that day in Wales, I felt like I'd been there for an hour, or longer, but in truth it was probably more like fifteen or twenty minutes. But to me it had been an hour; more, it had been my whole childhood, and all that time I'd been conversing, relating, understanding, remembering, and laying down another memory to take back with me to London. I'd never have got all that from a photograph, from a momentary pressing of a button. Snap.

◆

I keep drawing the trees, the rocks, the river,
I'm still learning how to see them; I'm still discovering
how to render their forms. I will spend a lifetime
doing that. Maybe someday I'll get it right.[9]

ALAN LEE (BORN 1947)
BRITISH ILLUSTRATOR

◆

DRAWING EXERCISE

CAPTURING TIME

This drawing exercise is almost a drawing project – an easy, accessible one, which can bring enormous pleasure over weeks, months or even years. It focuses on capturing a landscape and the passing of time within it. Again, you may use any medium for this and the time you choose to spend upon it is up to you.

● Choose a landscape subject that is near to you and which would be accessible on a regular basis. If you live in a town or city, as so many of us do, this may be something in your local park or even in your garden, if you're lucky enough to have one. Trees can make an excellent subject for this exercise. Even if you live in the heart of the metropolis, there is often a tree outside an office or apartment window, or a shrub growing nearby.

● Your task is simply this – to draw the same thing, once a week, for as long as you wish. I would suggest you do this for at least a month – or a season.

● As a variation on this, you could also choose to draw the same thing every day for one week, if you wish. Or even every few hours through one day.

● Drawing the same landscape regularly, over time, reveals aspects of it to us that a single drawing or expedition could never do. Returning to the same thing requires us to look at it afresh each time, to find something new and extraordinary even though we've looked at it a dozen times already, even though we've spent hours drawing it.

● Different things strike us when we draw through a longer period of time. We begin to notice the effects of light and shadow at different times of day. Leaves drop off a tree in the autumn, bud in the spring.

● And as well as what changes, we notice what doesn't change – or at least what changes so imperceptibly to our human eyes that it appears unchanging: the solid peak of the mountain, the shoreline, the curve of a river.

● There is something immensely satisfying in returning to draw a thing, or a place. And as we do so, we are led into an ever-deeper connection with and awareness of it.

Seeing the Preciousness of Things

We don't need to have a pencil in our hand to see clearly and intimately. Taking the time to really notice the things around us, to look at them with the intention of seeing their uniqueness, changes our relationship to them. This tree that you pass each day, there isn't another like it in the whole world. And it will be different tomorrow, and the day after. This is worth noticing. When we see in this way, we are reminded of the preciousness of life.

This phenomenon of timelessness, or what is more scientifically called altered *time perception*, is a recognised field of study within psychology and neuroscience.[10] Our subjective experience of time may be altered by emotions, drugs and age, for example, but there is increasing scientific evidence backing up the anecdotal, suggesting that mindfulness meditation lengthens the perceived duration of events. To practise mindfulness is to practise the art of timelessness.

Just imagine it. More time. More time to see. More time to draw. More time to be, to breathe, to be present. When we pause to be mindful, we become the pause, a little moment in space and time opens up for us, and what comes in – if we'll let it – is the whole world, our whole experience of it.

ENCOUNTERING IMPERMANENCE

As we encounter the element of time in drawing, we also begin to explore and make friends with the nature of change, the impermanence of the phenomena of the world – not as a theory, but as a reality in life and on the page.

TREES TURN GOLD, RUSSET, BROWN, their leaves falling to the ground to decay; mountains are eroded by water, by wind, even their edges are eventually blunted by the passing of time; and the hand that holds the pencil is changed too – lines appear, age spots, what was smooth becomes wrinkled.

*What if we could find the beauty
in decay, in the breaking and broken,
in the impermanence of it all?*

This awareness of the impermanence of things underlies the sense of unsatisfactoriness, of dukkha, that I wrote about earlier. Impermanence and unsatisfactoriness, there they are again. For some, they're the worm in the apple, the blot on the landscape, the dark shadow that overcasts the most beautiful of scenes. It will all pass, everything, it will pass and so will we. Like all good mindfulness practices, the mindfulness of drawing brings us into contact with the nature of reality; however, it also offers a positive way in which we can relate to this impermanence.

What if we could find the beauty in decay, in the breaking and broken, in the impermanence of it all? What if we could make impermanence the subject of our drawing – and in doing so, not just aestheticise it but also come to terms with it?

The Beauty of Impermanence
This mindful path to acceptance and even appreciation has already been marked out for us in the ancient Japanese tradition of aesthetics called *wabi-sabi*. Wabi-sabi, which evolved out of Zen Buddhism, is a philosophy that celebrates the

beauty of the impermanent. *Wabi Sabi Simple* author Richard Powell describes it like this: 'Wabi-sabi nurtures all that is authentic by acknowledging three simple realities: nothing lasts, nothing is finished, and nothing is perfect.'[11] The glory of wabi-sabi is that this acknowledging of reality applies as much to ourselves and our drawings as it does to the things we are seeing and that we choose to draw.

A dry, fading autumnal leaf could be said to be wabi-sabi. So could the paint peeling from an old door. The gate that I drew in Wales, crooked on its hinges, was wabi-sabi. So is the broken outline of the old gasworks on the horizon. So is the plastic bag caught in the branches of a tree, tattered and rustled by the wind. Wabi-sabi is a way of seeing the world so that even the small, ordinary and insignificant is viewed as precious, unique and beautiful. This way of seeing embodies a mindful awareness of the passing of time, the incompleteness of experience and an acceptance of this. This way of seeing

You discover how confounding the world is
when you try to draw it. You look at a car, and you try
to see its car-ness, and you're like an immigrant to your
own world. You don't have to travel to encounter
weirdness. You wake up to it.[12]

SHAUN TAN (BORN 1974)
AUSTRALIAN ARTIST, WRITER AND FILM-MAKER

DRAWING EXERCISE

WABI-SABI

This wabi-sabi drawing exercise is nice to do over an hour or so, when you have some free time; and because it's an exercise in discovering and capturing things that are wabi-sabi, it's especially good for city dwellers. If you plan to do your drawing out and about, then a small, easily portable sketchbook would be a good idea. Use pencil or pens to draw, or something else you can easily transport in a pocket. There are no particular time frames for this exercise – just take as long as you want, or as long as you can snatch.

If drawing on the hoof – perching on walls or on a step – doesn't appeal, you could take a lightweight, folding, drawing or camping stool with you, or simply photograph what you find mindfully, and then draw from your images at home. The instructions for this exercise are very simple and start with looking and walking.

• Just go for a walk along streets you know. Walk slowly and look at what's there. Walk and look with the intention of noticing the small things you wouldn't normally notice. Keep an eye out for shapes, colours, textures that appeal, irrespective of where you find them. The bright yellow of the old rubber glove I found on the street, one grey, drab, rainy day, was just as appealing as the yellow of daffodils in the spring, for example.

• Become accustomed to moving around where you live in this way – and if you have your sketchbook with you, or intend to draw, then make a record of what you find.

• You could even make each walk to the shop on the corner, each journey to work or return home a wabi-sabi scouting trip. Stay aware and present, notice what's around you and make a mental note, so that you can return to it at a later time with sketchbook in hand.

• When you do intend to make a sketch, take time to see, before you draw. You don't have to analyse why you find this thing interesting – that would be the thinking-mind approach, not the mindfulness approach; just accept that you do, and treat it as you would any beautiful thing. Indeed, allow your

drawing to reveal what it is that is appealing to you. Often it is only as we become immersed in drawing the texture of the peeling paint on a bench that we realise it was this that drew us to it in the first place.

- Just wander. Stop and start wherever you find something of interest, whether it's the broken TV aerial on the roof of the neighbours' house, or the rainwater glistening on the lid of a dustbin. Take a wabi-sabi tour around your neighbourhood. See how it changes familiar places.

- You could even set yourself a real challenge. Find something totally ugly, something you're convinced you can find absolutely no beauty in at all. Then draw it. See how you feel about it when you're done. Do you still think it's ugly? Maybe you do, maybe you don't, but I suspect drawing it will have changed your relationship to it, nonetheless.

- If you are taking photographs for drawing later, make sure you take a photo of your finds from all angles – or you could even take them home with you if they're easily transportable.

- Finally, try to find different focuses for your urban drawings. Move between drawing cityscapes – architecture, the lines of rooftops, the sky, the bigger picture – and the small intimate details at street level. Treat your city or town like a landscape and go exploring.

Taking Photographs

As we begin to cultivate the habit of seeing mindfully, of being present to the world around us, as we develop – in other words – our artist's eye, we may often encounter something we'd love to draw. After all, we're becoming more aware, we're more naturally open and on the lookout. However we're often not in a position to just whip out a sketchbook like a magician and get scribbling. We may be taking our eldest child to school, carrying heavy bags of shopping, or running late. We probably don't even have our sketchbook on us.

These opportunities, these finds, needn't be lost though. Most of us now carry phones with cameras, so it's still possible to record what we've found. So rather than scurrying on by, you could pause and take a photo.

Keep the same mindful attitude for taking photos as drawing, though. Don't just snap but take a moment to see, to be with what you're looking at – and then take your photograph. You can build a library of images to draw from later, but you'll have more sense of connection when you do this if you took a mindful pause when you first encountered things on the street.

enables us to view the world tenderly, so that even the broken, the decaying or the ugly become interesting and extraordinary. Implicit in wabi-sabi is the acknowledgement that we are the same, just as broken, incomplete, ordinary, just as beautiful, fleeting, unique.

As we practise the mindfulness of drawing and open to the world around us, wabi-sabi starts to become second nature to us. In encountering the workings of time through our drawings, and in moving into a deeper sense of connection to and awareness of what we draw, we naturally start to appreciate the small, hidden beauties in the most everyday and imperfect things and places.

This new way of seeing also lingers after we've put down our charcoal or our pens and put our sketchbooks away. Once our world view has adjusted, then everywhere we go is filled with examples of wabi-sabi, and impermanence is no longer something to be feared, but rather appreciated and accepted. Over time, wabi-sabi may ultimately help us to reflect on and come to terms with the impermanence of our own lives; but even at just a mundane level, it changes our relationship to beauty so that, pretty soon, we find beauty everywhere.

*Wabi-sabi changes our relationship
to beauty so that, pretty soon,
we find beauty everywhere*

CITYSCAPES

I've written at length about the power of landscape in this chapter, but now's the time to put in a good word for cityscapes, too. Towns and cities hold just as much potential for mindful drawing and exploring as the countryside. Cityscapes also offer countless examples of wabi-sabi.

THE MESH OF TRAIN TRACKS, overgrown with weeds at a busy junction; a rusting tin can, the label peeling off it in bright tatters; a skyline of cranes, towering over the concrete shells of half-finished apartment buildings; an abandoned rubber glove cupping a small puddle of rain in its palm; an oily bicycle chain, coiled and vertebraed like a serpent – these are all things that can halt me in my tracks, make me stop, look, admire. Noticing them adds a measure of beauty to my day, to my walk to teach a class, to the slog up the hill in the rain to buy food. My life would be immeasurably poorer without them.

Of course, it's not always possible to sketch the things we spot – we may be on our way somewhere in a hurry, or the street might be crowded, but with the mindful attitude of seeing we've developed in our drawing, we can at least pause and notice them. *Do pause, do notice them, please.* Better still, go out with the intention to be mindful, to notice the urban world around you, and to find wabi-sabi on the streets.

My own habit of mindfulness has become so ingrained that I carry these small eruptions of the broken and beautiful with me, even if I only encountered them for a moment.

A Mindful Relationship

Drawing changes our relationship to a place. We see it more. We enter into it more fully. We start to find more beauty, more value in the spaces we encounter, and develop a deeper intimacy and familiarity with them. Once this happens, it's much harder to treat them carelessly, inconsiderately – because we come to feel for them, we come to care.

Through the mindfulness of drawing, we discover one of the most profound aspects of mindfulness – that in our awareness, a natural sense of sympathy and empathy arises for the things we encounter. These may be things of the natural world, but they may also be other people, our own drawings, or even ourselves. Out of mindfulness, kindness can arise, concern and caring, compassion and understanding. With our sense of connection to the world around us affirmed, we no longer tread blindly through it; we feel more inclined to treat things and ourselves with loving-kindness.

With our sense of connection to the world around us affirmed, we no longer tread blindly through it

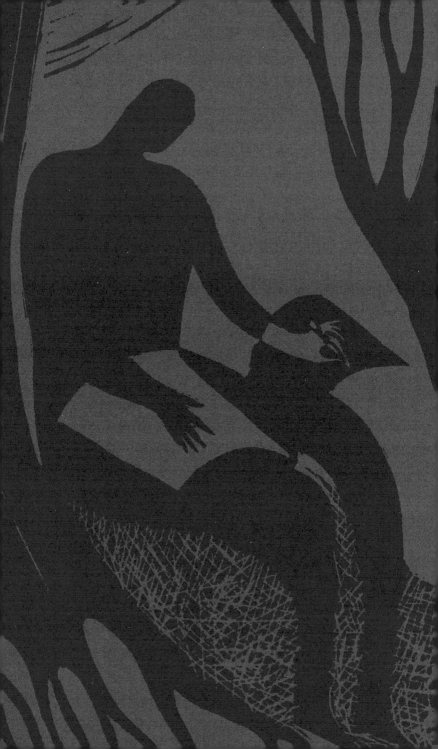

CHAPTER FOUR

PORTRAITURE
& LIFE DRAWING

How familiar the human form is to us.
We know instinctively the dimensions of the body,
the relative positions of our facial features; they are
hard-wired into our brains. And yet, as we'll explore
in this chapter, the mindfulness of drawing promises
a new way of encountering them, and, as our
mindfulness opens out into that natural empathy
for all things, it also offers the opportunity
to develop our capacity for loving-kindness
to an even greater extent.

DRAWING FIGURES

◆

So here it is, the human body, a form we are completely familiar with but that still has the capacity to surprise, arouse, beguile and astonish us. And here's the pencil in our hand, and we're going to draw it.

B UT HAVE WE EVER REALLY LOOKED at the human form closely before? I mean really looked at it, not just a cursory up and down in the mirror as we step from the shower, nor with the romantic gaze of a lover with all its subjectivities and projections. Maybe only as parents, marvelling at the extraordinary bodies of our newborns, do we really look at the human body, and notice its elegance, compactness, the perfection of how it's put together.

The exception to this not-really-looking trend can probably be found among the artists. Those who draw, those who paint, they have a unique perspective and relationship to the human form. An artist's attention to the human form goes beyond the personal; it understands the universal – the traits shared by us all – but also finds the unique in each individual body. Unlike our modern media's obsession with standardised 'perfection', its preoccupation with the waif-like, elongated bodies of models and actresses and the unrealistically muscled bodies and ever youthful faces of pop-stars and actors, it's noticeable that artists look for and value other kinds of beauty. Painters like Lucian Freud, Jenny Saville and

Maggi Hambling are fantastic examples of this. The subjects of their life studies are often old, overweight, craggy-featured, tattooed, bent and broken. And they are beautiful paintings.

A New Perspective

The mindfulness of drawing, the mindfulness of seeing, allows us to encounter the human body in a completely different way to the way we would normally. As such, it can reveal things we've never noticed before, even in relation to our own bodies. I remember very clearly the first time I did a self-portrait of my body. It was when I was first at art college. I did it in my bedroom, door firmly locked, stripping off in front of a full-length mirror propped against a wall, a large sheet of A1 paper and my materials on the floor. Like many of us, especially when we're very young, I had a few hang-ups about my body. It felt a bit uncomfortable transcribing it as a nude on the page. I felt slightly self-conscious, even though no one could see me and I certainly had no intention of showing the portrait to anyone. But I'd been doing all this life drawing at college and really enjoying it, and it just didn't make sense not to paint and draw myself at least once. Why wouldn't I choose to explore my own body in the way I had the life models who posed for us in class?

Now, I can't say it was a major revelation. I didn't suddenly cure all my adolescent-type hang-ups. But it was the first time I'd looked at the whole of my own body as an artist, and what

came out of this experience were two main things. Firstly, I noticed the proportions of my body – its curves, straight lines and planes, its mass – in a much more open and creative way. Suddenly my body was a site to be explored, understood and appreciated exactly how it was – it was complete and finished and didn't need to be changed. The proportions I might decry another time seemed normal, indeed beautiful with my artist's eye. It was the perfect subject for a drawing, no better or worse than any other human body would have been. Secondly, oh how much better a subject it was – because it *was* mine. I was already intimately acquainted with it, and yet here I was in the state of mindfulness that drawing and painting brought me, deepening that relationship, finding new aspects to it.

The Challenge of the Human Form

And yet despite the rewards and insights that drawing the human form in all its complexity can give us, it isn't without its challenges. We are conditioned to know instinctively the length of an arm, or the proportions of the eyes to the rest of the head, which means that when we draw someone, we know very quickly if our drawing is true to life, whether it measures up.

Draw a tree, and we don't have the same issue. Of course, every tree is unique, but get the trunk a bit too long on an oak and probably no one will notice; however, they may well pick up on it if it's the model you sketched in life-drawing class. So

it is that when we start to practise portraiture and life draw-ing, the first thing we have to deal with is both the exactness of the art, and also the natural arising of our inner critic in response to what we do. This makes drawing from life a fan-tastic mindfulness of drawing and seeing practice, as we are challenged not only to look more closely than we ever have before, but also to be kinder to ourselves about our drawings.

I find life drawing challenging, but this isn't to say that I don't enjoy it. I think the life-drawing sessions at art college were some of my favourite classes. Some people love drawing from life, others can take it or leave it, others actively dislike it. But of those in the latter category, I suspect it is the exact-ing familiarity of the human form and their frustrations at getting it 'right' that cause the large part of their antipathy. And since it does seem that portraiture is the area of drawing that most drawers come to later rather than sooner, perhaps for the very reasons I've just mentioned, it seems helpful to address head on any slight sense of trepidation or even intim-idation you may be experiencing.

Drawing With Loving-Kindness

What we need here is to come back to some of our core mindfulness principles, the ones we've already explored in this book, and to add in, quite deliberately, that quality of empathy and caring we've started to uncover in our mindful drawing experiences.

When we prepare to draw the human form, we need first to sit and see, really *see* what is there. We need to move constantly between seeing and drawing, eyes up and down from person to page. We need to relax, breathe, and just feel our own bodies drawing. We need to have a gentle awareness of the voice of our inner critic, and take mindful pauses when it gets too loud. We need to keep reminding ourselves, lightheartedly, of the nature of dukkha. We need to remember that we are not trying to get somewhere, or finish. It's the process not the product that counts, and we're drawing for its own sake. And we practise all this so that we may become absorbed into our drawing process, so that it flows, and we gain that sense of simply being. Out of this will naturally arise a greater sense of softness towards our efforts, we'll go a little easier on ourselves. But we don't have to stop there; we can deliberately cultivate that sense of softness, of kindness towards ourselves and our drawing – and the more we do, the more we'll enjoy it, and the better we'll feel about ourselves.

There is a word for this empathic, caring attitude in Pali – the word is *metta*, which can be translated as loving-kindness. And it is this quality of metta that develops naturally as we practise mindfulness, and which, if we wish, we can choose to make part of our mindfulness practice in more conscious ways too. And so for the rest of this chapter, we'll be exploring how drawing portraits and self-portraits enhances our capacity both for mindfulness and loving-kindness.

SELF-PORTRAITS

One of the first drawing exercises many of us do at school is self-portraiture. With a mirror in front of us, we attempt to copy our features on to the page, looking at our back-to-front image, trying to see our face as others see it.

HOWEVER, THE TRUTH IS that we most frequently look at ourselves in order to assess and judge rather than draw. In the looking glass, or in photographs, we mostly see ourselves in this assessing way. *Does my hair look OK or does it need a wash? Do my shoes match my suit? Why did I think that colour looked good on me? Am I getting wrinkles? I am getting wrinkles. I've put on weight. I'm overweight. I'm too thin. My hair's thinning.* And these are just the less vociferous, less judgemental thoughts. For many, a glance in a mirror or glimpse of a holiday snap can bring on an even greater critical response – *I'm ugly, everyone else looks better than me, no one will love me or find me attractive. I don't find me attractive. I don't love me.* Faced with our own physicality, our inner critic can get almost overwhelmingly loud.

So how can drawing ourselves possibly help? Won't all this looking at ourselves just make us feel uncomfortable or even downright miserable? The secret is all in the mindfulness, all in the intent. Just as when we looked for wabi-sabi and found the beauty in the impermanent, the broken, the ordinary, so too can we choose to look with kind eyes at our reflections

A portrait affirms; it gives the gift of self

to its subject. It says, 'Yes, you are worth spending this

time over, your story deserves to be told, you should be

recorded for you will not pass this way again.'[13]

DAVID GOATLEY (BORN 1954)
INTERNATIONAL PORTRAIT PAINTER

in the glass as we draw. And as we draw ourselves, we can seek to find the unique and the extraordinary in our normal, imperfectly perfect human forms. When we practise the mindfulness of drawing, we can move beyond the superficial standards of conformity and perfection that our media and culture overlay on the private territories of our bodies and faces. We can rediscover what is unique and beautiful about them with an artist's eyes, and with a kind heart.

Not Just What the Eye Can See

As we begin to practise more loving-kindness in relation to our own faces and bodies, so too can we find it in relation to our drawings on the page. Perhaps one of the biggest ways that we go wrong when we make those youthful self-portraits – and it's an attitude that carries over into adulthood, too – is to think that portraits, whether of ourselves or others, have to look *exactly like the person* and if they don't, we've failed. Now, of course, unless we're attempting a more expressionistic

or abstract figuration, we're going to want the proportions of our drawing to be as true to life as we can get them (and getting this right takes practice). However, a drawing is *not* a photograph. It is not a facsimile. A drawing contains the act of seeing by a unique human mind and heart. It contains interpretation, imagination and intuition about the subject of the painting. A drawn portrait captures not just what the eye can see, but also what the heart and mind can understand. It captures everything within the artist's awareness. And if that artist is practising the mindfulness of drawing, then that's quite a lot.

It's OK, therefore, if your self-portrait doesn't look exactly like you, as long as it captures something of your mood or personality, as long as it *feels* like you. Lucian Freud, the painter famed for his portraiture, put it this way. 'I would wish my portraits to be of the people, not like them. Not having a look of the sitter, being them.'

Let's return to that childhood drawing exercise, then, but let's bring to it our mindful attention, and our intention to look for the wabi-sabi in ourselves, to look kindly and with curiosity, as if we had never encountered our faces before.

*A drawing contains
the act of seeing by a unique
human mind and heart*

DRAWING EXERCISE

DRAWING IN THE MIRROR

For this drawing activity I suggest you use at least an A3 piece of paper, as this will enable you to draw your face life-size, without the extra challenge of having to change scale. You may use any medium, but a nice soft pencil would do very nicely.

Take as long as you wish to complete this self-portrait. You could experiment with giving yourself different lengths of time – drawing it in two minutes, five minutes, ten, or twenty. This turns the activity into a kind of game, and stops us from getting too hung up on end results and appearances. No one could possibly do a 'perfect' self-portrait in two minutes! So why not just do a quick, rough one instead? No pressure. Below are some pointers and suggestions for you as you draw.

• Set up your mirror so that you can see yourself clearly in it. Your mirror needs to be big enough to see the whole of your face, and preferably your shoulders too.

• It's important to get you and your mirror arranged comfortably for this exercise, so that you can glance up at your reflection easily, without having to crane your head or lean to one side.

• Begin by just breathing, feeling your hands as they hold the pencil and by simply looking at your face. See what is there as curves and lines, light and shadow, texture and form. Notice the colours of your skin, eyes and hair.

• As much as possible, see if you can view yourself as if for the first time. If familiar patterns of judging thoughts come up, just acknowledge their presence and then let them go. You might like to remember the difference between conceptualising and direct experiencing that we explored earlier. Can you simply experience your face?

• When you feel ready, start to draw from the inside to the outline – from the features out towards the jawline, hairline, chin etc. Mark out the main dimensions lightly as you have done for other drawings and gradually bring in more detail.

• Keep measuring with your eyes, looking particularly at the angles between elements – the angle of the line between the top of the ear and the eyebrow, for example, as well as the distance. Pay attention to negative spaces, those spaces that surround an object, or exist within it, that I mentioned earlier.

• Think about how light hits the planes of the face and try shading in these areas lightly. This helps to build up a three-dimensionality in the drawing taking shape on the page.

• If you wish to keep the mood light-hearted, you could try simply 'taking a line for a walk' around your face, never letting the tip leave the paper, doubling back on yourself when you need to. Make the pencil line a caress, as if you were blindly tracing the contours of your own features to understand them better.

• You could also try drawing your face without looking at the page to start with – as you did in earlier chapters.

• As you draw, remind yourself that your face, too, is full of uniqueness, full of beauty. Or, if this feels uncomfortable, you could simply wish yourself peace, enjoyment in your drawing today, a sense of satisfaction in just being creative, making this time for yourself.

• What I would wish for you is simply that when you finish your drawing you have been focused and absorbed, have had that sense of simply being – and that you have also encountered your own face in a subtly different way to normal. With enjoyment, and with ease.

What Are You Bringing to the Page?

Notice, as you prepare to do a self-portrait, what you're bringing to the experience. How do you react? What comes up? Is there a sense of excitement and curiosity, or is there trepidation or resistance at the idea of it? If there is, just sit quietly with this for a while. Notice these as sensations you feel in your body, perhaps as tension in your chest or hands.

If there is resistance or trepidation, notice if there is a critical voice attached to these sensations, these emotions. Are you bringing habitual unkind thoughts about your body, or appearance to this drawing exercise? Are you feeling mildly silly? Whatever comes up, take your mindful pause, just breathing gently. After all, this is just another form of self-criticism, and you're learning how to deal with this mindfully. Be kind to yourself. Let these feelings and reactions pass.

DRAWING FRIENDS & FAMILY

◆

There's something precious about being seen and drawn by another person and being granted permission to see and draw them. When we do this, we encounter each other in a way we haven't before, and in doing so we're entering into a new relationship with them.

ONE OF MY EARLIER MEMORIES is of being drawn by my older sister. In this memory I am sitting in a big armchair in our cottage in Wales. The chair is turned towards the window, and my sister sits between me and the light. I must have been about six or seven years old – my sister, ten years older. I remember how important being drawn made me feel. It seemed to confer specialness upon me. And being drawn by my big sister, who by then was launching out into the world, with less time for (no doubt annoying) younger siblings, made it doubly precious. For those few moments I felt very close to her; I felt seen. And then there was the surprise of seeing her drawing – seeing myself truly through someone else's eyes – not through a camera's lens.

When I lead mindful portraiture sessions I always put people in pairs, so that they can have the experience of drawing, but also the experience of being drawn. It is important, I believe, to have both in order to fully understand what happens when we draw another person, to get both sides of the story. In or out of classes, drawing friends or loved ones,

and drawing *with* friends, adds a new dimension to drawing, which can often be a solitary practice.

Drawing Closer

When I was at art college, I used to regularly visit my friend Anne at her house. Anne and I had met on a printmaking course originally, and our friendship developed somewhat during these classes, and later through a few trips to galleries; but I think those afternoon drawing sessions in her home really cemented this art-college friendship. We'd sip tea, chat amiably about our latest art projects, share our experience of the course, and take it in turns to draw each other, slipping into an easy familiarity with each other that grew over time. Initially I felt a little awkward, I think, lounging on Anne's sofa, while she sat opposite with her drawing board, looking at me intently. We're not used to being regarded so closely by people we don't know intimately – but gradually I got used to it, accustomed to being visible to her, and in doing so could let my guard down, relax. And then it would be my turn to draw, to get to know Anne in this completely different way, realising as I did so how precious it was. It's an experience I would recommend to anyone. It's such a creative, companionable and affirming way of building a friendship.[14]

When we draw portraits of others mindfully, barriers between the self and the other are broken down

When we draw portraits of others mindfully, practising the mindfulness of seeing as well as of drawing, barriers between the self and the other are broken down. The reciprocity between seer and seen, subject and subject – which I wrote about earlier – becomes even more palpable. And the empathy and sense of interconnection that arises naturally from our mindfulness can imbue this drawing relationship with a respectful appreciation for the being sitting before us in all their vulnerability and humanity. When we draw, we see people uncritically, but incredibly closely. We find the traces of their lives etched into their faces – the fine lines around the mouth and eyes, the softness of skin, the blurring of a jaw by time, a crease, a receding hairline, a frown or laughter line, all become incredibly poignant and beautiful. These are the very things our sitters may bewail in the mirror, or ignore – not wanting to see them, but they are the very things that make them human, that speak to us when we draw, that make us care about them almost tenderly, in all their imperfect, ageing, living, breathing beauty.

I work from the people that
interest me, and that I care about, in rooms
that I live in and know.[15]

LUCIAN FREUD (1922–2011)
BRITISH PAINTER

DRAWING EXERCISE

DRAWING IN PAIRS

The following drawing exercise is best done with a friend or classmate who also draws – however, it's still possible to practise with non-drawers too, such as family members or friends. I'd suggest a good-sized bit of paper for this – A1, or at the very least A2, and you can draw in a variety of mediums – charcoal, pencil, pastels, or even pen and ink.

• With your partner, spend some time together just sitting. Put your sketchbooks or drawing boards down and sit opposite each other, but looking at your hands in your lap or at a spot on the wall. Focus on your breathing and on the sensations in your hands for a little while, until you feel grounded. What sense do you have of that person sitting opposite you? What do you feel from them?

• Then raise your eyes and gently, with an intention of kindness and gentleness, look at your friend. You may like to take turns to do this, one person sitting with their eyes shut, just breathing, just having the experience of being looked at, and noticing what that's like, and then swapping roles after about five minutes.

• If you're the one looking, allow your eyes to rove over your partner's face. Have that intention to see them sensitively. Notice the vulnerability and openness of a human face when it's in repose, when it isn't talking. How is this experience of looking at your friend or classmate different from your usual one, in which you are both talking and interacting, but probably not really *seeing* that much?

• After you've each had five minutes of seeing, agree who will draw first and who will sit. Decide between you how it will be most comfortable for the sitter to position themselves, and also what the drawer's needs might be in terms of position or pose. Find a compromise that works for both.

• Also agree between you a drawing time and if you'll have breaks. The sitter might feel they need a break after fifteen minutes, for example. Or the drawer might want a half-hour pose.

- Also determine if you wish to talk as you draw, or remain silent. Make this whole process one of collaboration and agreement.
- If drawing, take the same approach as you did in the self-portraiture exercise to make your marks.
- In addition, as you draw your friend, you might like to take some mindful pauses for just seeing. During these pauses, can you increase your sense of mindfulness and insight in relation to your friend? You might like to try dropping some light questions into these quiet moments. *What is my friend's experience right now, in this moment? What are they feeling? What are they thinking?*
- You may also like to try wishing them well in these pauses, or as you draw. *May they be happy. May they be well. May they have love and contentment in life. May they enjoy their creativity and have time for it.*
- See how holding this generous intent, this attitude of conscious loving-kindness, changes your experience of drawing and of your connection with your friend.
- Allow the natural mindfulness of drawing to work itself. And then, when you're ready, switch places with your friend.
- If sitting, notice what it feels like to be looked at so intently. Is it comfortable or uncomfortable? Do you feel nervous or jittery, calm or contented? How does being drawn affect your sense of your friend? You might like to shut your eyes sometimes, going within, checking in mindfully on your experience. If you're not talking, use this as an opportunity to practise some mindfulness by focusing on your breath or the sensations of your body.
- You too may reflect on your friend's experience. *How do they feel drawing? Are they getting critical or are they just absorbed and in the moment? In what ways is their experience of drawing like yours? What do you share in this moment? How are you alike?* You may like to wish them well now, too. *May they feel at peace. May they be happy.*

continued overleaf

continued from previous page

• When you have been both sitter and drawer, take some time to sit opposite each other again, just breathing, just being aware of yourself and each other. When you finish, you might like to compare notes. If you've drawn with a friend before, how did adding the mindfulness and loving-kindness change the experience? How did you each find the experience of sitting? How did it change your awareness of your partner?

Once you've done this exercise – drawing portraits that focus on the head and shoulders of your partner – then, if you wish, you could also try drawing portraits of the whole of their body. This is valuable practice in drawing the full human form, in all its precise proportions. If you do this, it's good to be aware of the basic measurements of our bodies:

• On average, a human being's head fits into the total length of the body (crown to feet) seven and a half times.

• Notice, too, that limb lengths vary, but that on average the span of some-one's arms – fingertip to fingertip – is just a little longer than someone's total height.

• On average, leg length – from foot to hip – is approximately half the total body length.

• You can find lots of helpful diagrams of the relative proportions of the human body if you do a search online.

We Are Just the Same

For all our uniqueness as beings, we are, nevertheless, embarked on the same journey of living. And on this journey our experiences are broadly the same. We all need to love and be loved in order to survive and flourish in this world. We all experience pain and suffering, bereavement, loss, abandonment or rejection at some point. We all want a sense of stability and safety in our lives and struggle with insecurity and fear. We all have bodies that experience pleasure, comfort and gratification, and that also ache, get sick, worn out and age. We all experience the impermanence of life, of relationships and the physical world. We all have that sense of unsatisfactoriness, of dukkha.

In our drawing of people, and indeed of animals too, this sense of the shared nature of life, that we are – beneath the skin, beyond cultural, social, gender or economic differences – the same, can come into our consciousness to a greater extent. The natural empathy that arises from mindfulness facilitates a greater insight into the shared nature of our experience in the world. Our capacity for loving-kindness grows, we soften, we become a little more open to ourselves and to one another.

FACES IN THE CROWD

◆

I love people-watching. It's one of my favourite pastimes. I'm just endlessly fascinated by the ways people move, interact, dress. The expressions on their faces — of boredom, anxiety, happiness, excitement — tell me stories about their lives, leave me imagining what it would be like to be them.

SKETCHING THE FIGURES AND FACES of the strangers around us in train stations, libraries or cafés is an enjoyable addition to any mindful drawing practice. My flatmate at university, an Italian illustration student who'd get itchy-fingered if she wasn't drawing something, used to take her little sketchbook with her even on our nights out. By the end of the evening, her spiky, rapid pen drawings would have captured the overweight man leaning disconsolately over his pint; the wiry, drunk woman feverishly feeding the slot machine; a couple so wrapped up in each other they'd barely touched their drinks.

◆

Faces are the most interesting things we see;
other people fascinate me, and the most interesting
aspect of other people – the point where we
go inside them – is the face. It tells all.[16]

DAVID HOCKNEY (BORN 1937)
BRITISH PAINTER

◆

A crowded place, thronging with people, can be a wonderful place to draw.

Through sketching strangers from afar, we get the chance to experiment and practise drawing the whole of the human figure in motion or in repose. Observed from a distance, a human body may be reduced to a few lines, the curve of a shoulder, the angle of a leg as it stands, the pointed chevron of feet. Gestures and posture are more noticeable from a distance, too; personalities or emotions may be revealed by how people stand, walk, or sit.

The Flow of *Metta*

We're challenged to work fast when drawing crowds or groups – not to over-think our drawing, but simply to make marks rapidly and instinctively in response to what we see. Our hand dances over the page, we look up, we look down, our eyes trace a line – so does our pencil, and in just a minute a few scribbled lines may capture the dash of a man with a briefcase for a train, the slouch of a teenager on a bench, the taut, pregnant belly of a woman at a bus stop. This is drawing *as* seeing, so rapid, instinctive and absorbed that there's no time for analysis or composition; we just draw, we just see. And our aim isn't 'perfect' drawings, 'finished' drawings; our aim is to become immersed in the life around us, to notice the incredible variety of human interaction and activity, and enjoy it.

And beyond our enjoyment there is the space for something else, too – the flow of metta. As we bear witness through our drawing, as we draw closer to the lives that pass before our eyes and see our own experiences and emotions played out on their faces, in their bodies, our hearts can open to them; we can feel our kinship and wish them well.

Making Friends

Drawing people can be a wonderful excuse for social interaction, for moving beyond the bubble of the self. It's amazing how fascinating someone with a sketchbook can be to others. I know I personally can never resist craning to see the page of anyone I see out and about drawing. This can be a little off-putting for shy drawers, but you could also use it as a way of meeting new people, moving beyond yourself and even finding new subjects to draw.

If you're in a café and someone asks what you're drawing, or seems to be trying to sneak a peek – talk to them, say hello, ask them if they'd mind posing for you for five minutes.

Most people are flattered by requests like these (although sometimes self-conscious too). It's within your power to make someone feel your mindful loving-kindness and interest, to help them feel just as important and noticed as I did when I was a little girl being drawn by my big sister. So spread the gifts of drawing, allow your metta to flow through your pen or pencil and out into the world.

DRAWING EXERCISE

DRAWING CROWDS & GROUPS

For drawing crowds and groups, a small sketchbook is handy, one you can slip in a pocket or your regular everyday bag. That and a pen or pencil is all you need. Time – as long as you have to draw: five minutes on a train, a couple of minutes at a bus stop, half an hour in a café while you wait for the rain to ease off. Get into the habit of carrying this little sketchbook with you, and see what of life you can capture between its pages. Here are some suggestions and pointers.

• Try picking a spot, and give yourself an amount of time to spend there – say fifteen minutes. Spend some time just quietly taking this place in before you pick up your pencil. Draw anything that catches your eye.

• Keep your drawings quick, loose and fluid. You could try the 'taking a line for a walk' approach that I mentioned earlier in the book. Hold an attitude of openness and experimentation that will enable you to just see and draw as instinctively as possible.

• Treat this as an exercise in seeing and capturing, rather than making perfect drawings.

• Don't worry about capturing everything of a person or crowd scene, just little details.

• You could try drawing the same person over and over again. One little drawing after another, just a couple of minutes each time. Notice how these drawings differ and how they are the same. Does this repetition reveal aspects of your subject previously unnoticed? Does the repetition enable you to practise capturing lines – angles, the turn of a shoulder, the tilt of a head – better than if you were working on one drawing, rubbing out, redrawing, rubbing out, redrawing?

• How might you draw a whole crowd? Try just drawing the outlines of people with a few gestural marks to delineate limbs, a chin, the crook of an arm, a shopping bag. Sketch quickly to get the outline of a group standing together, the 'skyline' of heads.

CHAPTER FIVE

COMING
FULL CIRCLE

And so we come to the end. In this book
we've looked at the art of mindful drawing,
and along the way explored some of the traditional
areas of drawing you might like to practise — doodling
or abstraction, still life, landscape, portraiture and life
drawing. But the path of mindfulness and creativity
has no end point; rather it's an ongoing process of
discovery. And so in journeying to this final chapter
we aren't so much concluding as coming full circle,
returning to the beginning again.

FINDING SIMPLICITY

I've offered lots of ideas in this book, and numerous drawing exercises too – but now's the time to say, Keep it simple. *After all, it's the nature of drawing to lead us into greater mindfulness and awareness. It's not something we have to clutter with analysis or too much effort.*

HERE, I CAN DO NO BETTER THAN TO SHARE the six words of advice on mindfulness that continue to encourage me to keep it simple. These instructions, attributed to one of the great masters of mindfulness, Tilopa, who lived and taught in the eleventh century, are all I really need to know – on any given day – about the mindful path. The original six words are translated into English like this:

- Let go of what has passed
- Let go of what may come
- Let go of what is happening now
- Don't try to figure anything out
- Don't try to make anything happen
- Relax, right now, and rest.[17]

Keep it simple. *After all,*
it's the nature of drawing to lead us into
greater mindfulness and awareness

Try reading those aloud to yourself, let them sink in a little; and then you might like to try these too, my six words of advice, with a respectful bow to the master, Tilopa.

- Let go of how you drew yesterday
- Let go of the drawing you might do, one day
- Really experience drawing, as it is, right now
- Don't over-think it
- Don't force it
- Just relax. Just draw.

Learning to Let Go

In letting go of how we drew yesterday, we put aside whatever has come before and all our reactions to it – the wonderful drawing that we'll never possibly be able to reproduce, the terrible drawing that we think proved once again we're getting nowhere. We also stop holding on to any critical voices or judgements about our past drawings.

In letting go of the drawing we might do one day, we stay in the present moment, knowing that right here, right now is most important. We aspire to nothing, no big goals, no to-do lists, no requirements or pressures.

In having the intention to be completely present, neither in past or future, we enter into direct experience, simply being with whatever our drawing offers us, and letting it go too, allowing it to change and flow. Always in the present moment but holding it lightly.

Also, we put aside our ideas, concepts and analysis, which may include the voice of our inner critic. We even put aside the well-meaning advice of writers of books on Mindfulness in Drawing!

We stop trying to control, to fix, or to make ourselves or our drawings tense areas of *doing*. We're moving out of doing- and thinking-mind and into being-mind, remember? We also stop trying so hard. We ease off on striving.

And we just relax, and rest with our breath, with our drawing. We just draw.

Simple. And the more we can cultivate this attitude of simplicity, the better we get along with our drawing and our mindfulness practice. Keeping it simple stops us getting hung up on details. Keeping it simple takes the pressure off and allows us to revisit that experience of the mindfulness of drawing as a process unfolding. We remember that completion or perfection is not the point. After all, it's called drawing *practice,* mindfulness *practice.* Every day we keep it simple by just practising – not perfecting.

Practising Simplicity

Simplicity can also be a practical thing, finding expression in our actual drawings. Of course, we all have a natural style of drawing and I don't wish to interfere with that. Beyond any learned modes or schools or styles, drawing is unique to each individual artist – as personalised as our handwriting. Simple may not be your way of drawing, you may have a highly detailed style, and minimalism may not be your thing. But even then, there is room for simplicity, because simplicity isn't about style, it's about approach, and intention.

Even as we draw we can be checking in, asking ourselves, *Am I over-complicating this drawing? How much detail do I really need? Would less be more?* With an intention for simplicity, we can focus on what is essential in our drawing, what is really needed to convey what we are seeing. Keeping it simple, we may also catch the point when finishing off a drawing turns into fiddling. Beware of fiddling – it often leads to clutter, or undoing things in our drawing that were actually fine. Much of this questioning is a natural part of our drawing process

I'm interested in locating
the holy grail of the minimum means to
express the most complex ideas.[18]

BEN NICHOLSON
BRITISH ARCHITECT & AUTHOR

anyway, as we assess and notice the progress of our sketch on the page. But just hold this intention for simplicity, and see what it does for you. Perhaps you find a more simple, uncluttered approach that feels right for you.

A Way of Being

Simplicity can also be seen as an expression of the clarity and spaciousness of mindfulness that allows the body to move and create uninhibitedly. In the Japanese Zen tradition, this idea of an artist free to make marks that are an expression of the uniqueness of their own being in the moment is explored through the drawing or painting of circles – called *ensõ*.

Ensõ – sometimes called Zen circles – are made with one continuous movement of brush or pen. Ensõ are a sacred symbol in Zen Buddhism, where they represent infinity and enlightenment. They also stand for the oneness of life, completeness, emptiness, harmony, and, of course, simplicity. There is an extraordinary beauty and elegance to ensõ, and it is the minimal nature of the single brushstroke on the page, the closed (or sometimes partially open) circle, that makes them so.

How difficult it is to be simple.

VINCENT VAN GOGH (1853–90)
DUTCH POST-IMPRESSIONIST PAINTER

Ensō, as a symbol, also represents the artist, the maker of the mark. The artist's mind is revealed in it, captured in the act of creating it, along with their acceptance of imperfection, for it is almost impossible to draw a perfect circle. The ensō *is a drawing that is the manifestation of a single moment* and of all an artist is or isn't within that moment. Within its form is held the life of the drawer, their mind, heart and body, as it flows through their arm, through the pen or brush and onto the page. Every ensō is different, each circle varying in the tones of ink, mark or brushstroke, the shape of the circle, even in the point in the circumference where the artist chose to start. Ensō are in this way a complete expression of individuality.

Every ensō is different, each circle varying in the tones of ink, mark or brushstroke … Ensō are in this way a complete expression of individuality

There is something extraordinarily peaceful about ensō; there is so much space in them, and yet they are contained, balanced. In drawing them, we come back to the pleasure of simple mark-making that we explored earlier. You could draw an ensō a day. You could draw one after each sitting meditation, if you practise sitting meditation. You could start or end your drawing sessions with ensō, too. Get a group of friends together, all drawing ensō – compare them, notice how they all vary, and share your experience of drawing them.

DRAWING EXERCISE

DRAWING ENSŌ

Here are some simple instructions for drawing ensō in the manner of the Zen tradition. You will need an A4 sheet of paper, a stick of charcoal, or, if you wish to practise more traditionally, a watercolour brush and ink. Try working simply in black, blue/black, or a sepia or ochre colour.

● Bring your materials together mindfully, arranging them carefully and taking time to enjoy them.

● Close your eyes and visualise an ensō. See that circle in your mind's eye, holding a sense of what it represents traditionally and also what it might mean to you. Be aware of your breath – another circle within your being.

● Take your charcoal in your hand, staying aware of how it feels and how you are grasping it.

● If you are using a brush, load it with enough ink or watercolour to make a circle in one single stroke or gesture – without needing to reload the brush.

● Breathe in deeply and draw your ensō.

● Remember – this is one moment in time, all that you are, all that is, in this one mark on the page.

● Traditionally, ensō are accompanied by a sacred text, a koan or quote from spiritual texts or sutras. You might like to add some words to your ensō – a mantra, an affirmation, an expression of gratitude, whatever you wish. Or you may leave the paper with just its circle.

● Sign your ensō and then place it somewhere you'll see it regularly, so that it can remind you of the importance of mindfulness, of the simplicity of the present moment.[19]

COMING FULL CIRCLE

Now I've given you all this guidance – written at length about my own journey and how you can embark on yours – I suggest you try to forget everything I've said. Don't ignore it, but shelve it somewhere in your mind for now, and just draw. Let drawing be your guide.

THE CREATIVE PATH TO AWARENESS isn't something we can plot out formally and empirically, or that will behave properly, staying in the place we order it, appearing in the ways we expect. There isn't a map that we can join the dots on – *I'll start at* focus – *travel on to* absorption – *then I'll head over to* flow – *and after that let's visit* simply being *and* opening to the world. *That's it, journey done. Path of awareness – complete.* As you will have discovered if you've done any of the mindful drawing exercises in this book, our awareness and our experience of mindfulness varies every time we come to it. Some days our focus is good, others it's

The creative path to awareness isn't something we can plot out, appearing in the ways we expect

not. One time we may feel ourselves effortlessly opening out into a state of simply being, at peace with ourselves and what we're drawing, another time we're grouchy and out of sorts, critical of our every effort. In one drawing session we may

have a profound sense of empathy and connection, a sense that we are not separate from the person or thing we are drawing, and our heart opens – and then that sense may elude us for days, or weeks, or months, or even years.

Always a Beginner

If we try to hang on to these things, or if we even strive for them, we miss the point – which is that we can only be here, *now*, with our current experience, and allow drawing to be our guide, our teacher. What we have to do is let go, surrender to the path of mindful drawing even though we don't know where it's taking us, even if where we're going may seem to be backwards. What we have to do is to unlearn everything we've learned, go back to the beginning and start as beginners each time we sit down with our sketchbook. Beginner's mind again, and again, and again.

This isn't to say that we don't progress with our practice. If we're coming back to the beginning, then it is a spiral we're travelling – going ever deeper, rather than a closed loop. Our drawing skills may become sharper. So too our mindfulness of seeing will develop, our observational skills, our sensing skills. With time, our capacity for stillness and for awareness does expand and deepen – but still we don't really know where this will take us, or what it might lead to.[20] It's more that the path is formed out of our current experience, out of our drawing. The path is created by where we are *now*.

All we need do is choose to be mindful of what is here, what our experience is today, and open to it, coming back to the beginning again.

The ideas I've shared in this book have come out of my own practice of both mindfulness and drawing, and may act as signposts along the way for you, helping you to recognise your path when it rises up to meet you, and stay on it when you encounter difficulties. But in the end it's drawing itself that is and will be your greatest teacher. May your journey with it be blessed. May you be at peace with your drawing. May you find happiness and mindfulness. May your creativity flourish and benefit not just yourself, but everyone you know.

ENDNOTES

1. Taken from www.barbarahepworth.org.uk/texts

2. If you're interested in learning more about the neuroscience of mindfulness, then you might like to read *Buddha's Brain; The Practical Neuroscience of Happiness, Love, and Wisdom*, Dr Rick Hanson (New Harbinger Publications, Oakland, California, 2009).

3. *The Spell of the Sensuous*, David Abram, p68 (Vintage Books, New York, 1997).

4. The fourth Noble Truth comprises a practical series of instructions on living, which the Buddha taught could lead all beings into liberation from *dukkha*. This spiritual instruction manual is called the Eight-fold Path or, sometimes, the Middle Way.

5. 'The Mayo Tao', Derek Mahon, from *Collected Poems* (Gallery Press, Oldcastle, Ireland, 1999) and *Selected Poems* (Penguin, London, 2000).

6. *Mindfulness and the Natural World*, Claire Thompson, p66 (Leaping Hare Press, Lewes, UK, 2013).

7. Constable's quote on the delight, beauty, trouble and pain of landscape painting: a letter to Rev. John Fisher, 22 July 1812; as quoted in *Letters of the Great Artists: From Blake to Pollock*, Richard Friedenthal (Thames and Hudson, London, 1963).

8. *Great Paintings*, Bridget Riley (Dorling Kindersley, London, 2011).

9. *The Lord of the Rings Sketchbook*, Alan Lee (Houghton Mifflin Harcourt, Boston, 2005).

10. For example: 'The effect of mindfulness meditation on time perception', R.S. Kramer, U.W. Weger, D. Sharma; *Consciousness and Cognition*, September 2013; 22(3):846–52. doi: 10.1016/j.concog.2013.05.008. Epub 2013 Jun 15. PubMed PMID: 23778017.

11. *Wabi Sabi Simple: Create Beauty, Value Imperfection, Live Deeply*, Richard R. Powell (Adams Media, Fairfield, Ohio, USA, 2004).

12. *Sketches from a Nameless Land: The Art of Arrival*, Shaun Tan (Hachette Australia, Sydney, 2010).

13. David Goatley, www.thewords.com/gallery/davidpage1.htm

14. After art college I moved away, and over time Anne and I lost touch. But recently, thanks to social media, we are back in contact again. Anne went on to be an art teacher and a couple of years ago started practising mindfulness meditation. She was very interested to hear I was writing a book about drawing and mindfulness!

15. www.arthistoryarchive.com/arthistory/contemporary/Lucian-Freud.html

16. www.davidkrutpublishing.com/5390/hockneys-potraits-and-people-marco-livingstone-and-kay-heymer

17. According to Ken McLeod, a notable translator of traditional Buddhist texts, the original text contains exactly six words; the English translation given is attributed to him.

18. www.archinect.com/features/article/14916/ben-nicholson-s-faith-based-initiative

19. These instructions are based around those on the Modern Zen website: www.modernzen.org/enso.htm

20. Although in the traditional spiritual context of mindfulness practice, the ultimate destination is said to be enlightenment or *nirvana*: liberation from the cycle of unsatisfactoriness and suffering, of death and rebirth.

FURTHER INSPIRATION

◆

This isn't going to be your standard Further Reading list. Instead, I wanted to include a collection of resources that would help to inspire you, wake you up, make you present and alive to the beauty of the world and to your own experience. It's an eclectic mix of books, artists and links to videos and websites that I hope will get you even more enthusiastic about mindfulness and drawing.

Drawing Inspiration
Links to a couple of blogs in which artists explore the practice of a drawing a day. Maybe they'll inspire you to try this, too.
www.onedrawingaday.com
www.davidsdrawingaday.tumblr.com

Jake Spicer: Drawing Out Wonder
Interesting TEDx Talk on drawing and perception.
http://tinyurl.com/jakespicer

There are many ways to approach drawing and many different styles – as many paths as there are artists to take them. Here are three artists who've had interesting drawing journeys, just proving that anyone and everyone can draw.

Stephen Wiltshire is an extraordinary contemporary autistic artist who was mute until the age of five. For him, 'drawing was his speech, his language'.
www.stephenwiltshire.co.uk
http://tinyurl.com/swiltshire

Self-taught Polish 'outsider' artist Edmund Monsiel, an untreated schizophrenic who was deeply religious, produced a vast body of incredibly detailed drawings during his lifetime.
www.outsiderart.co.uk/monsiel.html

Artist Heather Hansen comes to drawing through her work as a dancer and theatre performer and uses her whole body to draw.
www.heatherhansen.net
http://tinyurl.com/heatherhansen

Three artists whose drawings have inspired me:
Egon Schiele: Copies of his complete works – hundreds of drawings of the human figure – online here: www.egon-schiele.net

Philip Hughes, British landscape artist: *Patterns in the Landscape: The Notebooks of Philip Hughes* by Glenn Murcutt (Thames & Hudson, London, 1998)

Pablo Picasso: If you've only ever looked at his paintings, his drawings and prints may be a bit of a revelation. Just enter 'Picasso line drawings' into an internet search engine and have a look at the images you find.

Mindfulness Inspiration
Sam Winston: Drawing Breath
British artist's version of the mindfulness of breathing – a drawing of the breath completed over 15 hours.
www.samwinston.com/artworks/drawing-breath

If you'd like to explore mindfulness as a practice outside of drawing, here are a couple of books to dip into, both of them suitable for all levels of experience:
Peace Is Every Step: The Path of Mindfulness in Everyday Life by Thich Nhat Hanh (Rider, London, 1991)
Wildmind: A Step-by-Step Guide to Meditation by Bodhipaksa
(Windhorse Publications, 2nd Edition, Cambridge, 2010)

Tara Brach is an American mindfulness teacher with a whole host of meditations and talks on her website: www.tarabrach.com. This short video introduces a simple meditation for pausing mindfully in the midst of our busy lives.
http://tinyurl.com/tbrach

Sharon Salzberg, who has written several books about the loving-kindness mindfulness practices, talks here about including this heart-opening meditation into her experience each day.
http://tinyurl.com/sharonsalzberg

If you'd like to find out more about mindful drawing, I blog regularly on creative mindfulness at www.artofmindfulness.org.uk. You can also join the online Art of Mindfulness Facebook community by clicking the Like button. Finally, do come find me on Instagram @artofmindfulness if you'd like to see some of my own mindful drawing.

THE MINDFULNESS SERIES

◆

Mindfulness in Baking
Julia Ponsonby
ISBN: 978-0-711288-23-2

The Art of Mindful Gardening
Ark Redwood
ISBN: 978-0-711288-17-1

The Art of Mindful Silence
Adam Ford
ISBN: 978-1-908005-11-3

The Art of Mindful Singing
Jeremy Dion
ISBN: 978-1-78240-419-4

The Art of Mindful Walking
Adam Ford
ISBN: 978-1-907332-58-6

*Einstein & the Art of
Mindful Cycling*
Ben Irvine
ISBN: 978-1-908005-47-2

*Galileo & the Art of
Ageing Mindfully*
Adam Ford
ISBN: 978-1-78240-243-5

Happiness & How it Happens
The Happy Buddha
ISBN: 978-1-907332-93-7

The Heart of Mindful Relationships
Maria Arpa
ISBN: 978-1-908005-29-8

*Meditation & the
Art of Beekeeping*
Mark Magill
ISBN: 978-1-907332-39-5

Mindfulness & Compassion
The Happy Buddha
ISBN: 978-1-78240-288-6

Mindfulness & Surfing
Sam Bleakley
ISBN: 978-1-78240-329-6

*Mindfulness & the
Art of Managing Anger*
Mike Fisher
ISBN: 978-1-908005-30-4

*Mindfulness & the
Art of Urban Living*
Adam Ford
ISBN: 978-1-908005-77-9

*Mindfulness & the
Journey of Bereavement*
Peter Bridgewater
ISBN: 978-1-78240-206-0

*Mindfulness & the
Natural World*
Claire Thompson
ISBN: 978-1-78240-102-5

Mindfulness at Work
Maria Arpa
ISBN: 978-1-908005-76-2

Mindfulness for
Black Dogs & Blue Days
Richard Gilpin
ISBN: 978-1-907332-92-0

Mindfulness for
Unravelling Anxiety
Richard Gilpin
ISBN: 978-1-78240-318-0

Mindfulness in Knitting
Rachael Matthews
ISBN: 978-0-711288-21-8

Moments of Mindfulness
ISBN: 978-1-78240-251-0

Naturally Mindful
ISBN: 978-1-78240-416-3

Zen & the Art of
Raising Chickens
Clea Danaan
ISBN: 978-1-907332-38-8

Zen & the Path of
Mindful Parenting
Clea Danaan
ISBN: 978-1-78240-154-4

INDEX

ACKNOWLEDGEMENTS

*Firstly, I would like to express my deep gratitude and
thanks to the mindfulness teachers, dharma practitioners,
and retreat centres who have guided and supported me in my
mindfulness journey over the years – especially Lama Karma Chime
Shore, the Dorje Chang Institute in Auckland, and the Brighton
Buddhist Centre. Secondly, my students, the courageous and creative
people who teach me far more than they will ever know; and Tessa
Chisholm at Evolution Arts, who first gave me the opportunity to
share my vision of creative mindfulness. Finally my thanks go
to Monica Perdoni, Jayne Ansell, Jenni Davis and everyone at
Leaping Hare Press for their encouragement and enthusiasm,
and for showing up and saying, 'Will you write a book?' – just
when I was thinking, 'I want to write a book.'*

Deep bow to all.